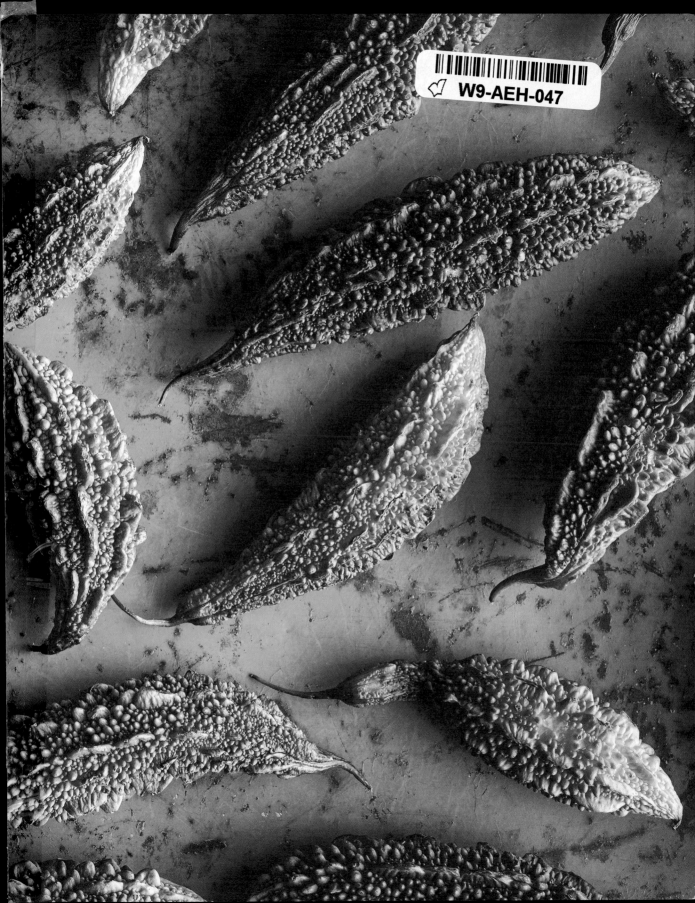

CHETNA'S

healthy

indian

**EVERYDAY MEALS
EFFORTLESSLY GOOD FOR YOU**

CHETNA'S

healthy indian

CHETNA MAKAN

MITCHELL
BEAZLEY

To my kids, Sia and Yuv

An Hachette UK Company
www.hachette.co.uk

First published in Great Britain in 2019 by Mitchell Beazley,
an imprint of Octopus Publishing Group Ltd, Carmelite House,
50 Victoria Embankment, London EC4Y 0DZ
www.octopusbooks.co.uk

Distributed in the US by Hachette Book Group, 1290 Avenue of the Americas,
4th and 5th Floors, New York, NY 10104

Distributed in Canada by Canadian Manda Group, 664 Annette St,
Toronto, Ontario, Canada M6S 2C8

ISBN 978-1-78472-535-8

A CIP catalogue record for this book is available from the British Library.

Printed and bound in China.

10 9 8 7 6 5 4 3 2

Commissioning Editor: Eleanor Maxfield
Art Director: Juliette Norsworthy
Senior Editor: Leanne Bryan
Photographer: Nassima Rothacker
Food Stylist: Emily Kydd
Props Stylist: Morag Farquhar
Assistant Production Manager: Lucy Carter
Cover Designer: AKA Alice

Contents

Introduction

Before I start telling you about this book, let me be clear: in no way does it outline a diet or a fad-eating plan. Nor do I give advice on how to get lean or lose weight! I am no health freak. I never even feel as though I go out of my way to eat a healthy diet. This is simply an honest cookbook that brings you into my kitchen so I can share my favourite everyday recipes with you – they just happen to be good for you.

I was brought up in a family where Mum cooked amazingly delicious food from scratch every day, never cutting corners or taking short cuts. Our dining table is where my love of food began. The fantastic meals she prepared for us were all fresh and healthy, and they tasted divine. I believe it is because I was raised on such a deliciously good diet that I've never in my life felt the need to count calories.

Of course, in those days in India we didn't have canned food, bottled cooking sauces, spice packs, ready meals and so on, which meant for most people there was not much choice but to cook from scratch most of the time. I would see my aunts and neighbours all cooking for their families too, making meals that were healthy and, by necessity, quick to put together. We did eat in restaurants sometimes, and enjoyed the street food, but these were occasional treats, enjoyed greatly, but only from time to time.

My mum would buy fresh veg from the street vendor who came calling to our road every morning, and choose her dishes for the day based on what he was selling. If she bought enough vegetables, he would throw in some green chillies and a lime for free, so you can imagine how fresh our meals were. I remember the panic on my mum's face on days when the vendor did not show up!

I was very lucky that Mum is an amazing cook. We were totally spoiled by her wonderful spreads every day. She would cook a fresh meal for lunch and another one for dinner, and she still does so to this day. The same cannot be said of me! But I still believe in the nutritional value of cooking from scratch, so if I am preparing a dal or some curry, I make enough to feed our family for a couple of days.

"I was brought up in a family where Mum cooked amazingly delicious food from scratch every day"

My mum was lucky in having the shops come to her, so to speak. I can't imagine any of the people I know – myself included – going to the shops every day to buy fresh ingredients for each day's meal. I do, however, try to visit my local farm shop once a week. I go and see what fresh produce they have, then plan my meals accordingly, which means we eat a lot of seasonal and local produce.

The idea for this book came about because of one simple question that I, as a food writer and baker, am asked all the time. That is: "How do you eat all this gorgeous food every day and still stay the same size?" I've lost count of the number of times this question has been put to me. And every time someone asks it, the first thing that pops into my head is: "I just eat healthy food."

I've been sharing everyday meal recipes on my YouTube channel, Food with Chetna, for a few years now, because I like to show people how easy it is to make good Indian food – which is really healthy – at home. It's such a joy to hear of people who have never cooked Indian food before trying my recipes, and then adopting them as regulars because their family loves them. This has given me more confidence to bring you into my kitchen and to share with you my everyday meals.

Over the last few years, the interaction I've had with people on social media has helped me to see that many people expect Indian home cooking to be like the standard takeaway – greasy, oily and basically unhealthy. But this is the opposite of what you would find in any Indian home kitchen!

So, to counteract this idea, in this book I want to show people the healthy food I cook every day for my family. This collection of recipes includes dishes my mum made when I was little. Some are recipes of hers that I've adapted over the years. There are dishes that came about to satisfy my children's likes and dislikes.

Some dishes are favourites of mine, others are things I really enjoy cooking. There are many recipes that I've developed to showcase healthy ingredients that I love.

My dad is a vegetarian, which meant we always had predominately vegetarian food at home, with fish and chicken occasionally appearing on the table. Things are the same in my kitchen now – my husband is vegetarian, so I cook a lot of meat-free food on a daily basis, but my kids love fish and chicken, so they appear in our meals now and again.

As you'll see, my go-to recipes are vegetarian and contain lots of fresh, seasonal vegetables, which are not only low in fat but packed full of nutrients and fibre, which we all know are good for you.

I also tend to cook a lot with lentils – a great source of protein, fibre, vitamins and much more. They are easy to store and cook, so are brilliant for midweek meals. But the best part, as far as I'm concerned, is the huge variety of lentils there is to choose from. Each type has a unique texture and flavour; if I specify a type of lentil in a recipe and you choose another one, the result will not be as intended. Don't worry – it can still taste great, but factors such as the flavour, texture and cooking time will need to change. So please do try to use the specified lentils in each recipe to get the best results.

All the food in this book is effortlessly healthy. I like to create recipes and cook using simple ingredients – things I can buy in local shops, farm shops and supermarkets. No one wants to spend ages trying to order things online or looking for speciality ingredients. The spices I use are basic ones you can get hold of easily, and once you buy them you will be able to use them for many recipes.

I am not a doctor or a health specialist, but what I do know is that the food I cook uses a minimum of oil and ghee; that the produce, whether it is vegetables, fish or chicken, is fresh; and that the basic spices are good for you. Follow my lead and you will be creating healthy, delicious meals for your family, regardless of the odd splash of cream or occasional sprinkling of sugar here and there.

I love salads, which the first chapter focuses on (*see* pages 12–33). For me, salads need a bit of substance – not just a few leaves. I include things like paneer, chicken and beans in salads, so that they are light and fresh with lots of flavour, but satisfying, too.

The Vegetables chapter (*see* pages 34–73) covers a variety of veg. Most of the vegetables I use tend to

be available locally grown, and are readily available in farm shops or supermarkets. I have thrown in a couple of recipes that use Indian vegetables, and I really encourage you to give them a go. Things like okra and bitter gourd should not be too difficult to source and provide an enjoyable change of pace.

"I like to show people how easy it is to make good Indian food – which is really healthy – at home"

Next comes a chapter on Lentils & Grains (see pages 74–109). Lentils offer so much variety and flavour, from black dal to moong dal to red kidney beans and toor dal... all are delicious and amazing. These simple, tiny things have real punch and pizzazz when cooked the right way, and could easily become a staple of your daily meals. (You will notice that I keep jumping between the words dal and lentils throughout this book and that is purely because they mean the same thing. You can use the terms interchangeably.)

The Fish chapter (see pages 110–25) is a collection of flavour-packed yet super-simple curries. Living by the sea, I am lucky to be able to obtain really fresh fish, which is so quick to cook, yet the results taste divine. Fish, as you must know, is a great source of protein, and contains lots of minerals, including calcium and much more, making it a very healthy choice.

Chicken, the next chapter (see pages 126–49), is my favourite. I love a good chicken curry – to me, it's the perfect comfort food. Chicken is not just delicious, but brilliant for all its protein, minerals and vitamins. The dishes in this chapter vary from a light and creamy coconut curry to a blast of sensational flavours in my chicken with pickling spices dish. You'll also find a whole roast chicken, and some amazing soups.

The next section is an important one as flatbreads and rice are a key part of any Indian meal (see pages 150–69). I've made sure the rice recipes here are varied and many work perfectly as meals on their own, whether you fancy prawn rice or mushroom and onion. The flatbreads are also brilliant and can be served with any of the curries in this book.

All my friends know how much I love chutneys and pickles – I include some in every book I've written and there's a whole chapter on them in this one (see pages 170–83). I believe adding a good chutney to your meal can make it extraordinary. The ingredients used in them are super-healthy too.

Please don't be fooled into thinking that sweets can be made without sugar or any naughty stuff. What you can do is enjoy a modest portion. The recipes in my Sweets chapter (see pages 184–201) contain a minimum of sugar and ghee, but still have all the flavour you need for a good finish to a meal.

I hope that these recipes will become a part of your family meals as much as they are a part of mine.

Menu Plans

The beauty of the dishes in this book is that they can be enjoyed on their own, or with some rice or chapatti, and most of them are really easy to prepare, making them perfect for midweek meals. But if you are cooking for a big family gathering or a get-together with friends, you will want to cook more than one dish, and this is where the following menu ideas will come in handy.

For these menu plans, I have suggested combinations of recipes on the basis of their complementary flavours and ingredients, making them ideal for serving together as a large meal to share. They are based on one or two main dishes being the star of the show, with supporting cast in the form of side dishes and relishes.

1

Red Kidney Bean Curry
(*see* page 91)

+ Mango & Mint Salad (see page 29)
+ Masala Cauliflower Potatoes (see page 61)
+ Garlic Pickle (see page 172)

4

Tadka Dal with Tomato, Red Onion
& Coriander (*see* page 92)

+ Asparagus & Pea Salad (see page 17)
+ Cumin Potatoes (see page 44)
+ Mango Pickle (see page 177)

7

Spicy Chickpea & Chicken Curry Bake
(*see* page 141)

+ Mango & Mint Salad (see page 29)
+ Five Lentils (see page 79)
+ Tomato & Peanut Rice (see page 160)

8

Creamy Tomato & Fenugreek Curry
with New Potatoes (*see* page 52)

+ Stuffed Peppers (see page 50)
+ Chana Dal with Roasted Aubergine (see page 86)
+ Prawn Pulao (see page 166)

11

Quick Mustard Prawn Curry
(*see* page 122)

+ Sprouted Moong Sabji (see page 108)
+ Baked Chicken Biryani (see page 162)
+ Tomato, Garlic & Chilli Chutney (see page 175)

12

Red Gurnard in Banana Leaf
(*see* page 119)

+ Fine Bean, Coconut & Tamarind Salad (see page 22)
+ Butternut Squash, Chickpea & Spinach Soup (see page 76)
+ Aubergine Pickle (see page 180)

2
Onion & Whole Spice Chicken Curry
(*see* page 145)

+ Potato & Courgette Salad (see page 18)
+ Black Lentils with Red Kidney Beans (see page 84)
+ Mango & Mint Chutney (see page 179)

3
Yogurt Curry with Roast Carrot
& Red Onion (*see* page 40)

+ Chickpea Salad with Cherry Tomatoes & Coriander (see page 24)
+ Paneer & Purple Sprouting Broccoli Sabji (see page 65)
+ Ginger & Tamarind Chutney (see page 176)

5
Red Lentils with Spinach
(*see* page 87)

+ Fine Bean, Coconut & Tamarind Salad (see page 22)
+ Spicy Stuffed Okra (see page 49)
+ Hot & Spicy Coconut Prawns (see page 113)

6
Chicken & Potato in Pickling Spices
(*see* page 133)

+ Sweet Tomato & Curry Leaf Salad (see page 14)
+ Paneer & Cavalo Nero Saag (see page 38)
+ Fenugreek & Gram Flour Flatbreads (see page 157)

9
Smoky Aubergine with Peas
(*see* page 46)

+ Sweet Tomato & Curry Leaf Salad (see page 14)
+ Butternut Squash with Red Lentils & Tamarind (see page 100)
+ Peppercorn & Red Chilli Chicken Curry (see page 131)

10
Spicy Chickpeas with Sea Bass
(*see* page 80)

+ Beetroot Salad (see page 19)
+ Aubergine Coconut Curry (see page 36)
+ Spicy Masala Roast Chicken (see page 132)

13
Gram Flour Dumplings in Tomato Curry
(*see* pages 68)

+ Smoky Aubergine with Peas (see page 46)
+ Chicken with Kale & Yogurt (see page 146)
+ Pearl Millet & Potato Flatbreads (see page 158)

14
Cashew & Tomato Curry with Eggs
(*see* page 70)

+ Cumin Potatoes (see page 44)
+ Masala Black Chickpeas (see page 104)
+ Rice with All The Greens (see page 165)

Sweet Tomato & Curry Leaf Salad

Asparagus & Pea Salad

Potato & Courgette Salad

Beetroot Salad

Fine Bean, Coconut & Tamarind Salad

Chickpea Salad, Three Ways

Mango & Mint Salad

Chicken Salad with Yogurt Dressing

Cumin Paneer Salad

Salads

What a delicious way to make the humble tomato side salad the star of the show! The juicy baby tomatoes are refreshing, the curry leaves bring fragrance, the chilli gives the dish a good punch and the lentils add texture. This versatile salad goes well with any dal or curry, with chicken or fish. It's also good simply served with rice or chapatti.

Sweet Tomato & Curry Leaf Salad

SERVES 4

1 tablespoon split chickpeas (chana dal)

1 tablespoon split white lentils (safed urad dal)

1 tablespoon sunflower oil

1 teaspoon black mustard seeds

pinch of asafoetida

10 curry leaves

1 small green chilli, finely chopped

¼ teaspoon salt

500g (1lb 2oz) sweet baby tomatoes, halved

Soak the chickpeas and lentils together in a bowl of water for 1 hour, then drain. Set aside.

When ready to cook, heat the oil in a saucepan over medium–low heat. Add the mustard seeds and asafoetida and let them sizzle for a few seconds, then stir in the curry leaves and green chilli. Cook over high heat for another few seconds.

Throw the chickpeas and lentils into the saucepan and mix well. Cover the pan with a lid, reduce the heat to low and cook for 5 minutes, until the chickpeas and lentils are firm but no longer rock hard.

Add the salt and tomatoes and cook over high heat for a final minute. Serve warm or cold.

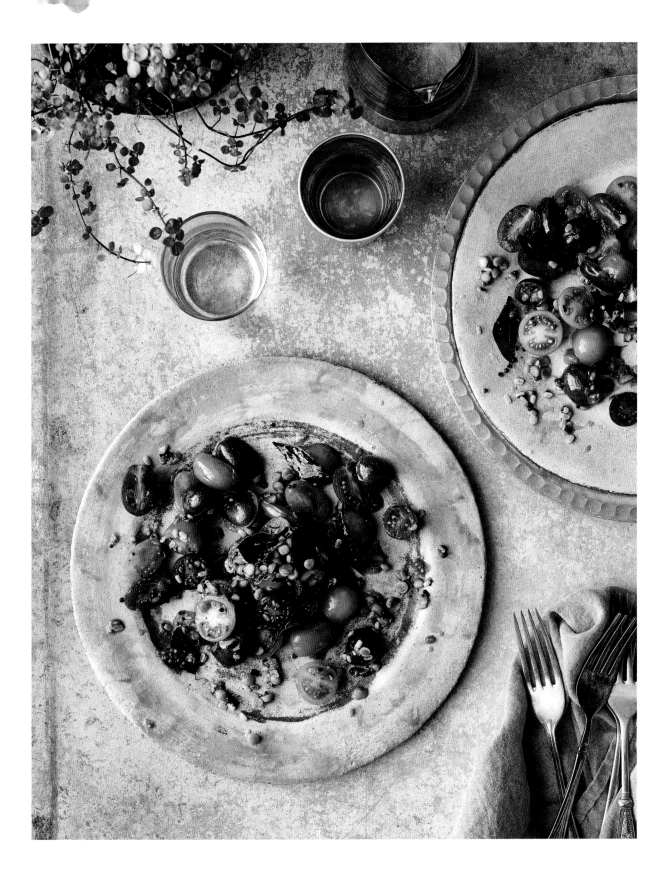

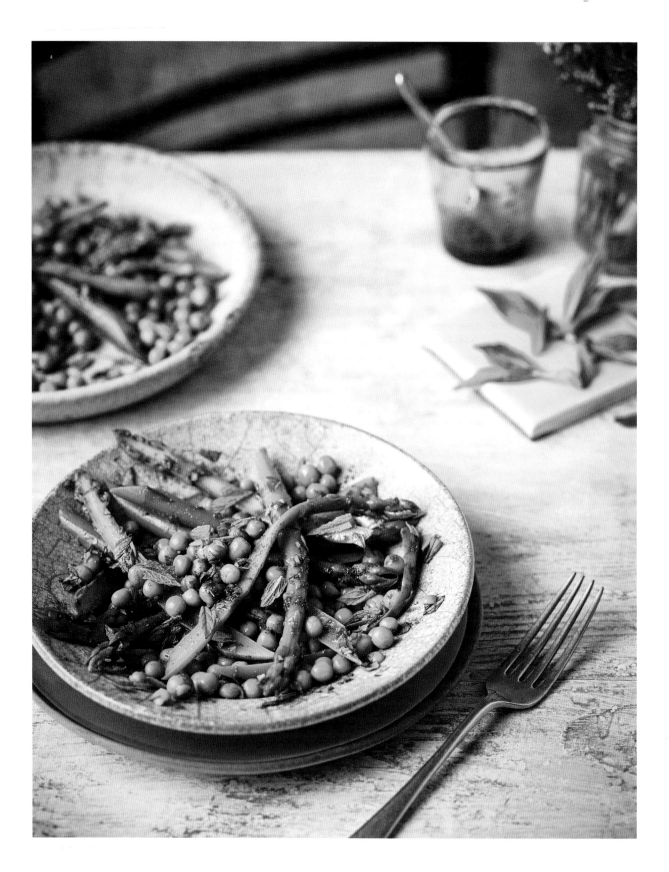

The combination of asparagus and peas is a classic one, and mint is often added to bring freshness to the mix. In this dish, spices also work their magic to make a crisp, light and truly delicious spring salad. Serve it alongside lentils or vegetable sabji with rice.

Asparagus & Pea Salad

SERVES 2

200g (7oz) asparagus
200g (7oz) fresh or frozen peas
handful of fresh mint leaves, finely chopped

For the dressing
¼ teaspoon chilli powder
¼ teaspoon ground cumin
¼ teaspoon ground ginger
pinch of salt
pinch of freshly ground black pepper
1 tablespoon extra virgin olive oil

Bring a saucepan of salted water to the boil. Add the asparagus and boil for 2 minutes, until the asparagus is half cooked. Now add the peas and boil for another 2 minutes, until the vegetables are cooked through. Drain well and tip the vegetables into a serving bowl.

In a small bowl, combine the spices, seasoning and oil and stir until smooth. Pour this mixture over the asparagus and peas, add the chopped mint and toss well. Serve warm or cold.

This delicious salad is not only refreshing but also wonderfully filling. Mustard and lime is a beautiful combination that adds a lovely zing to the griddled potatoes and courgettes. Serve this dish on its own or with some rice or flatbreads.

Potato & Courgette Salad

SERVES 4

400g (14oz) baby new potatoes, halved lengthways

1 tablespoon sunflower oil

2 courgettes, shaved into long, thin slices

20g (¾oz) fresh coriander, leaves and stems finely chopped

20g (¾oz) fresh dill, finely chopped

1 red chilli, thinly sliced

40g (1½oz) walnuts, roughly chopped

For the dressing

1 tablespoon English mustard

1 teaspoon lime juice

¼ teaspoon salt

¼ teaspoon freshly ground black pepper

1 tablespoon olive oil

Put the potatoes into a saucepan and cover with water. Bring to the boil, then reduce the heat and simmer for 5–6 minutes, until the potatoes are just cooked. Drain well.

Heat the oil in a griddle pan over medium–high heat and lay the potato pieces in it with the cut sides facing down. Cook for 2–3 minutes or until golden. Transfer to a large bowl.

Cook the courgette ribbons on the griddle pan for 3–4 minutes, until golden, then add them to the bowl of potato halves. Throw in the coriander, dill, chilli and walnuts.

Mix together the dressing ingredients in a small bowl, then pour the dressing over the vegetable salad. Toss well and serve immediately.

Tender, juicy beetroot and red onions is a sublime mixture. The spicy glaze used here develops in the oven into a delicious coating. Just before serving, I add crunchy lettuce and toasted seeds, with a touch of lime juice for a sharp and fresh note.

Beetroot Salad

SERVES 4

500g (1lb 2oz) beetroot, peeled and sliced

2 red onions, thinly sliced

1 red gem lettuce, thinly sliced

juice of ½ lime

1 tablespoon toasted sunflower seeds

1 tablespoon toasted pumpkin seeds

¼ teaspoon freshly ground black pepper

For the glaze

2 garlic cloves, thinly sliced

1cm (½ inch) piece of fresh root ginger, peeled and thinly sliced

1½ tablespoons sunflower oil

½ teaspoon salt

½ teaspoon ground cumin

3 tablespoons water

Preheat the oven to 180°C (350°F), Gas Mark 4.

Put the beetroot slices into a roasting tin with the glaze ingredients and mix well. Cover the tin with kitchen foil and roast for 30 minutes, until the beetroot is half cooked.

Remove the foil from the roasting tin and discard. Add the red onions to the tin and mix well. Roast, uncovered, for a further 30 minutes or until the beetroot is tender – test it with a knife, which should slide into the flesh easily.

Tip the contents of the roasting tin into a bowl, cover and leave to rest for 10 minutes.

Add the lettuce, lime juice, toasted seeds and black pepper to the bowl. Toss well and serve immediately.

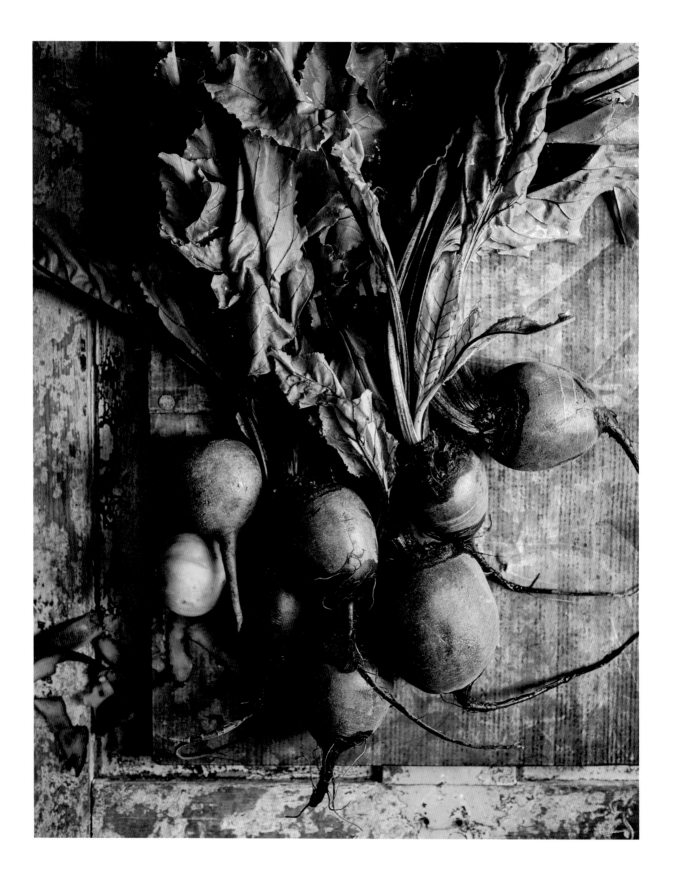

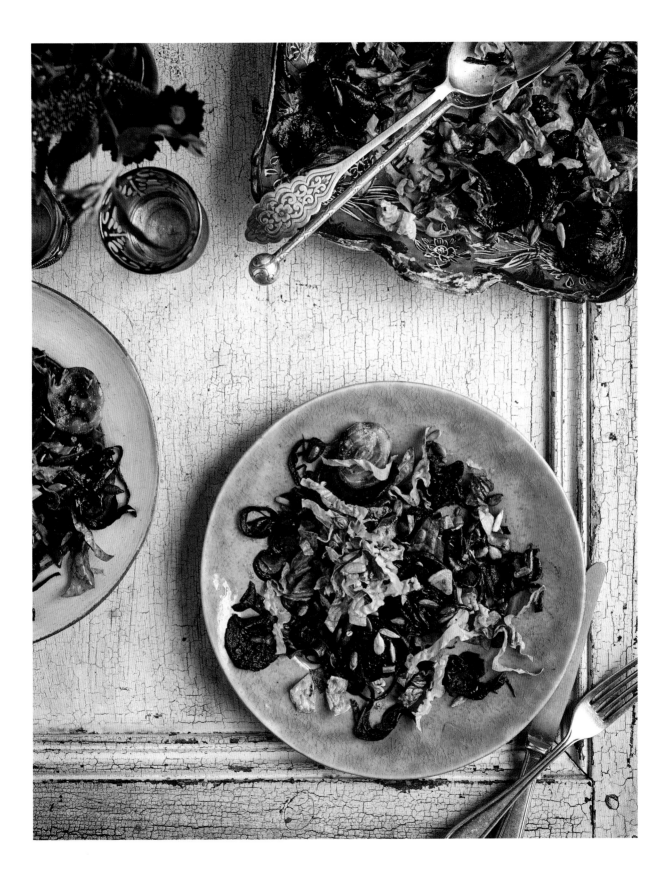

The fact that this dish is very simple to put together belies how refined it is. Every single ingredient plays an important role, from the nutty oil to the vibrant curry leaves, sharp mustard seeds, hot chillies, sour tamarind paste and chewy coconut. Serve it warm or cold with pulao or dal.

Fine Bean, Coconut & Tamarind Salad

SERVES 4

350g (12oz) fine green beans, halved

3 tablespoons chopped fresh coconut

1 tablespoon groundnut oil

1 teaspoon mustard seeds

10 curry leaves

2 dried red chillies

1 teaspoon tamarind paste

¼ teaspoon salt

Cook the beans in a saucepan of boiling salted water for 4 minutes, then drain and refresh them under running cold water.

Put the coconut into a mini food processor and pulse until it is very finely chopped and resembles desiccated coconut. Set aside.

Heat the oil in a saucepan over medium–low heat. Add the mustard seeds and cook for 1–2 minutes, until they begin to pop. Stir in the curry leaves and dried red chillies and let them sizzle for a few seconds.

Reduce the heat to low and add the tamarind paste, salt and chopped coconut. Throw in the boiled beans, increase the heat to high and cook for 1 minute only. Serve immediately.

ways with

Who would have thought that the combination of chickpeas, cucumber and onions could taste so special? Chutney adds a lovely zing to this simple and delicious salad, which is a meal in itself. Any of the three toppings I suggest below are great with this dish, but if you choose to add all three together, the result is fabulous!

Chickpea Salad, Three Ways

SERVES 2

400g (14oz) can chickpeas, rinsed and drained

1 cucumber, diced

1 small red onion, diced

2 tablespoons Mango & Mint Chutney (see page 179)

¼ teaspoon salt

Put the chickpeas into a bowl with the cucumber, red onion, chutney and salt and mix well.

Spoon the chickpea salad into a serving bowl, add the topping or toppings of your choice (*see* pages 26–7) and serve immediately.

1 with spicy chicken

2 with cherry tomatoes & coriander

3 with spicy potatoes & mint

Chickpea Salad, Three Ways

1

with spicy chicken

200g (7oz) skinless chicken breast fillet
pinch of salt
pinch of freshly ground black pepper
pinch of chaat masala
1 tablespoon sunflower oil

Lay the chicken breast on a chopping board between 2 sheets of clingfilm.
Using a rolling pin, flatten it a little by hitting it lightly all over, ensuring that
it is of an even thickness. Remove the clingfilm and sprinkle over the salt,
pepper and chaat masala. Rub the spices into the flesh.

Heat the oil in a frying pan over medium heat. Add the chicken and fry for
8–10 minutes, turning once or twice, until the chicken is cooked. Transfer to
a chopping board and leave to cool slightly, then shred or cut the chicken
into small pieces.

2

with cherry tomatoes & coriander

300g (10½oz) cherry tomatoes, halved
pinch of salt
pinch of freshly ground black pepper
10g (¼oz) fresh coriander leaves, finely chopped
1 teaspoon lemon juice

Combine the ingredients in a bowl
and mix well.

3

with spicy potatoes & mint

1 tablespoon sunflower oil
¼ teaspoon salt
¼ teaspoon chaat masala
2 medium potatoes (skins on), boiled and diced
10g (¼oz) mint leaves, finely chopped

Heat the oil in a saucepan over low heat.
Add the salt and chaat masala, then the
potatoes and mint leaves. Increase the
heat to high and cook, stirring, for
2 minutes, until well combined.

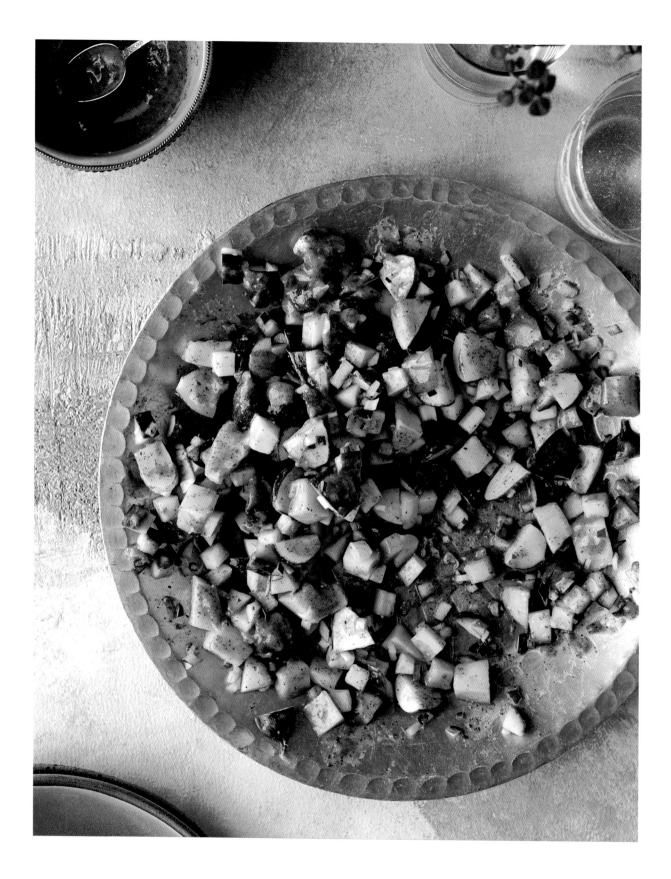

This vibrant, refreshing salad makes a terrific accompaniment to any dish in this book, whether it be vegetable, chicken, fish or dal. The mango's sweetness is offset by the chilli kick and the zingy taste of mint, while cucumber and radish add lightness and crunch.

Mango & Mint Salad

SERVES 4–6

½ mango, peeled and diced
1 cucumber, diced
20–25 small radishes, quartered
1 small red onion, finely chopped

For the dressing
½ mango, peeled and chopped
juice of 1 lime
2 garlic cloves, roughly chopped
¼ teaspoon salt
¼ teaspoon freshly ground black pepper
10g (¼oz) mint leaves (roughly a handful)
1 small green chilli
1 tablespoon extra virgin olive oil

Put all the dressing ingredients, except the oil, into the bowl of a mini food processor and blitz to a paste. With the motor running, slowly add the oil and continue to blitz until the mixture emulsifies and becomes creamy.

Put the salad ingredients into a serving bowl. Add the dressing and toss well. Serve at room temperature, if you like, or pop the salad into the refrigerator to chill for 10 minutes or so, which is also great!

Shallots, tomato and curry powder combine to make a yogurt dressing to die for in this delicious Indian-style chicken salad. You could serve it as a main meal or as a side dish and, come lunchtime, it also makes a great wrap filling.

Chicken Salad with Yogurt Dressing

SERVES 4

300g (10½oz) skinless chicken breast fillets

¼ teaspoon salt

1 teaspoon medium curry powder

1 teaspoon sunflower oil

1 romaine lettuce heart, thinly sliced

250g (9oz) small radishes, thinly sliced

juice of ½ lime

For the dressing

1 tablespoon sunflower oil

2 banana shallots, finely chopped

1 red chilli, finely chopped

1 tablespoon tomato purée

2 tablespoons water

¾ teaspoon salt

1 tablespoon medium curry powder

100ml (3½fl oz) natural yogurt

Lay the chicken breasts on a chopping board and cover them with clingfilm. Using a rolling pin, flatten them a little by hitting them lightly all over, ensuring that they are of an even thickness. Remove the clingfilm, sprinkle over the salt and curry powder and rub well.

Heat the oil in a wide frying pan with a lid over low heat. Lay the chicken in the pan, then cover with a lid and cook for 10–12 minutes, turning once, until the chicken is cooked through. Remove the chicken from the pan and set aside to cool.

Next, make the dressing. Using the same frying pan you used to cook the chicken, heat the oil over low heat. Add the shallots and red chilli and cook for 5 minutes, until softened. Stir in the tomato purée and measured water,

then cover the pan with a lid and cook over low heat for 5 minutes, until the purée is cooked. Stir in the salt and curry powder and cook for a final minute, then take the pan off the heat and leave the mixture to cool slightly. Tip the spice mixture into a bowl, add the yogurt and mix well.

Shred the cooked chicken and add it to the yogurt dressing, stirring until thoroughly combined.

Put the thinly sliced lettuce and radishes in a serving bowl. Add the chicken and yogurt mixture along with the lime juice and toss well to coat the leaves and radish in the dressing. Serve immediately.

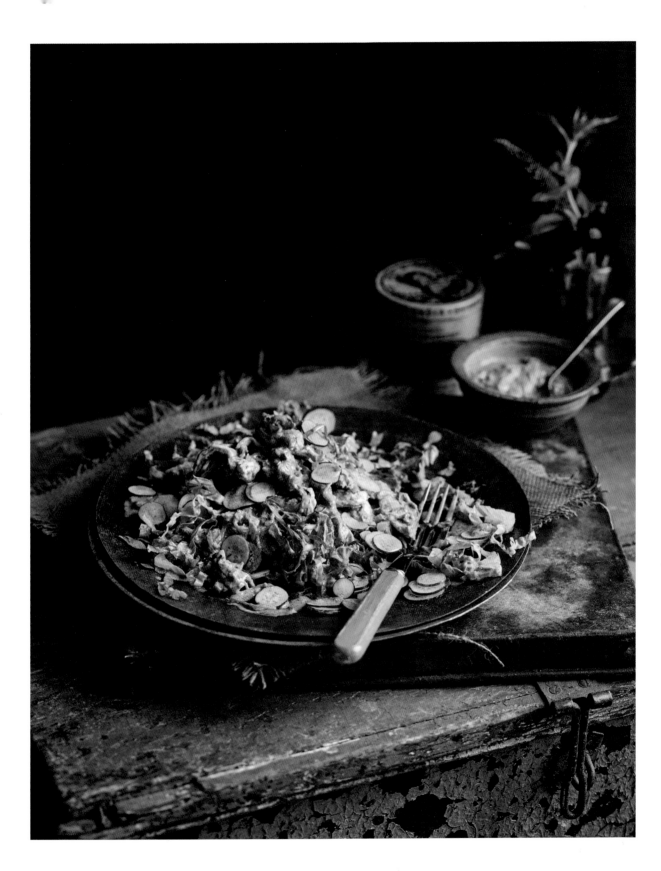

If you are craving a salad that has a massive flavour kick and a crisp, crunchy texture, it's time to reach for this recipe. The peanut, garlic and chilli dressing will bring any combination of mixed salad leaves to life, while yogurt makes the delicious cumin-flavoured paneer soft and creamy. To transform this into a vegan recipe, replace the paneer and yogurt with some grilled cauliflower or roast potatoes.

Cumin Paneer Salad

SERVES 4

100ml (3½fl oz) natural yogurt
½ teaspoon ground cumin
½ teaspoon ground turmeric
½ teaspoon salt
1 tablespoon sunflower oil
225g (8oz) paneer, cut into rectangles
200g (7oz) mixed salad leaves
sliced red chilli, to garnish

For the dressing
2 teaspoons olive oil
6 garlic cloves, roughly chopped
25g (1oz) toasted peanuts
1 red chilli, roughly chopped
¼ teaspoon salt
2 tablespoons water

Firstly, prepare the paneer. Combine the yogurt, cumin, turmeric and salt in a bowl. Add the paneer pieces, mix well and leave to marinate for 10 minutes.

To make the dressing, heat 1 teaspoon of the oil in a large frying pan over medium heat. Add the garlic and cook for 1 minute, then add the peanuts, chilli and salt and cook for a few seconds more.

Transfer the peanut mixture to a mini food processor, add the remaining oil and the measured water and blitz the mixture to a paste.

Set the frying pan you used to make the dressing over medium heat. Heat the sunflower oil then add the paneer pieces and fry for 1 minute on each side, until slightly golden. Transfer them to a bowl, cover closely with clingfilm (to keep the paneer soft) and set aside while you prepare the salad.

Arrange the salad leaves in a large serving bowl. Pour over the dressing and toss well. Lay the paneer pieces on top, scatter over some sliced red chilli to garnish and serve immediately.

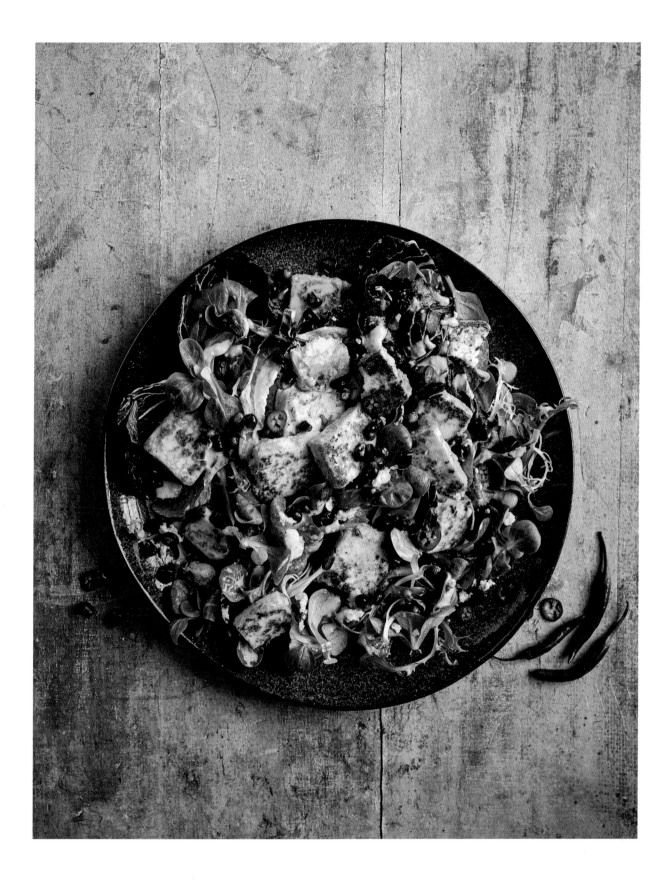

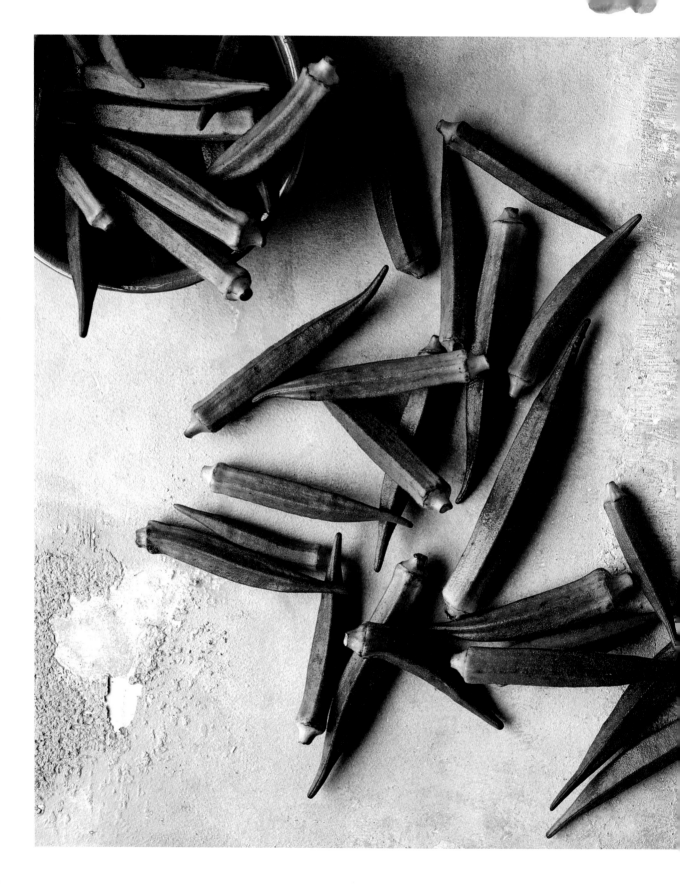

Aubergine Coconut Curry

Paneer & Cavolo Nero Saag

Yogurt Curry, Four Ways

Cumin Potatoes

Cabbage, Pea & Carrot Sabji

Smoky Aubergine with Peas

Spicy Stuffed Okra

Stuffed Peppers

Creamy Tomato & Fenugreek Curry, Three Ways

Sweet Potato Yogurt Curry

Mushroom Paneer

Cumin Pepper & Paneer

Masala Cauliflower Potatoes

Spicy Bitter Gourd with Onions

Paneer & Purple Sprouting Broccoli Sabji

Potato & Coriander Soup

Gram Flour Dumplings in Tomato Curry

Cashew & Tomato Curry, Four Ways

Vegetables

As long as it is fully cooked, aubergine tastes amazing. This dish is quick to put together, so is perfect for serving midweek, and it showcases the delicious flavour of aubergine using nothing more than some basic spices and a can of coconut milk. You can't go wrong! Serve it with chapatti or rice.

Aubergine Coconut Curry

SERVES 4

1 tablespoon sunflower oil

1 teaspoon brown mustard seeds

2 red onions, thinly sliced

1 red chilli, thinly sliced

1cm (½ inch) piece of fresh root ginger, peeled and julienned

1 large potato, cut into thin wedges

1 aubergine, cut into thin wedges

½ teaspoon salt

1 teaspoon garam masala

½ teaspoon chilli powder

½ teaspoon ground turmeric

400ml (14fl oz) can coconut milk

Heat the oil in a saucepan over medium–low heat. When the oil is hot, stir in the mustard seeds. After 1–2 minutes, when they begin to sizzle, add the onions and chilli and cook for 7–8 minutes or until the onions begin to turn golden. Add the julienned ginger and cook for 1 minute.

Stir the potato, aubergine, salt and remaining spices into the saucepan, then increase the heat to medium and cook for a couple of minutes, ensuring the mixture is well combined.

Pour the coconut milk into the saucepan, then cover the pan with a lid, reduce the heat to low and simmer gently for 15–20 minutes or until the aubergine and potato are fully cooked. Serve immediately.

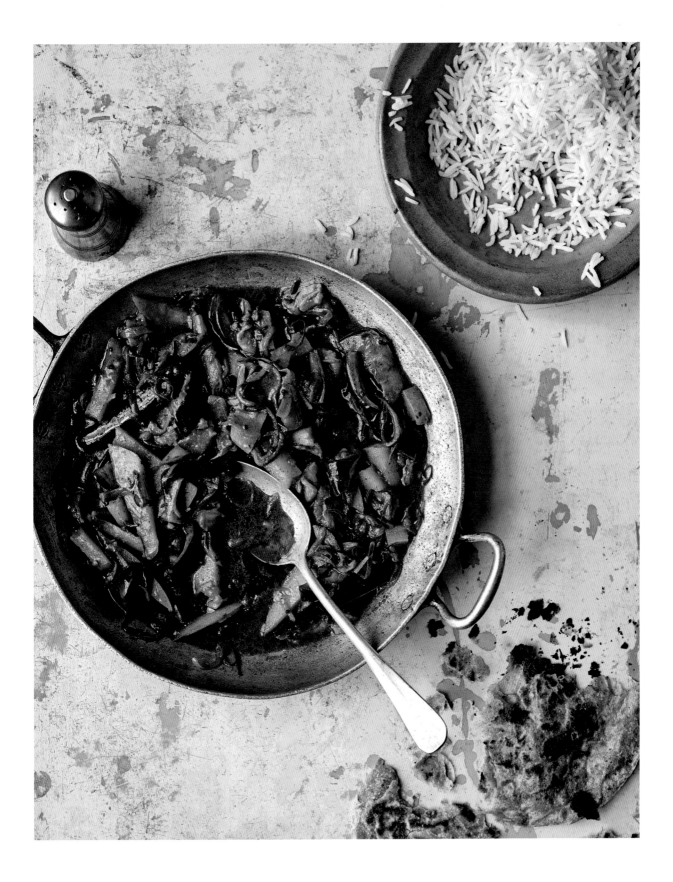

Smooth and creamy, this absolute stunner of a curry is made in minutes and is perfect served with chapatti. The cavolo nero (also known as black cabbage or Tuscan kale) adds a wonderfully woody depth of flavour. For a vegan version, use oil instead of ghee, omit the cream and replace the paneer with cooked potatoes or tofu – or just leave it out and enjoy the luscious combination of spicy spinach and cavolo nero.

Paneer & Cavolo Nero Saag

SERVES 4

200g (7oz) cavolo nero, roughly chopped

200g (7oz) spinach, roughly chopped

200ml (1/3 pint) boiling water

1 tablespoon ghee

2 garlic cloves, finely chopped

1 teaspoon salt

1 teaspoon chilli powder

225g (8oz) paneer, cut into small dice

1 tablespoon double cream

Place the cavolo nero and spinach in a saucepan over low heat and pour in the measured boiling water. Cover the pan with a lid and cook for 5 minutes, until the leaves have wilted. Allow to cool a little, then transfer the mixture to the jug of a blender and process it to a purée.

Heat the ghee in a saucepan over medium–low heat. Add the garlic and let it sizzle for 1 minute, then stir in the spinach purée, salt and chilli powder. Cover the pan with a lid and cook gently for 5–7 minutes, until cooked through.

Stir the diced paneer and cream into the saucepan and cook for a final 2 minutes, then serve immediately.

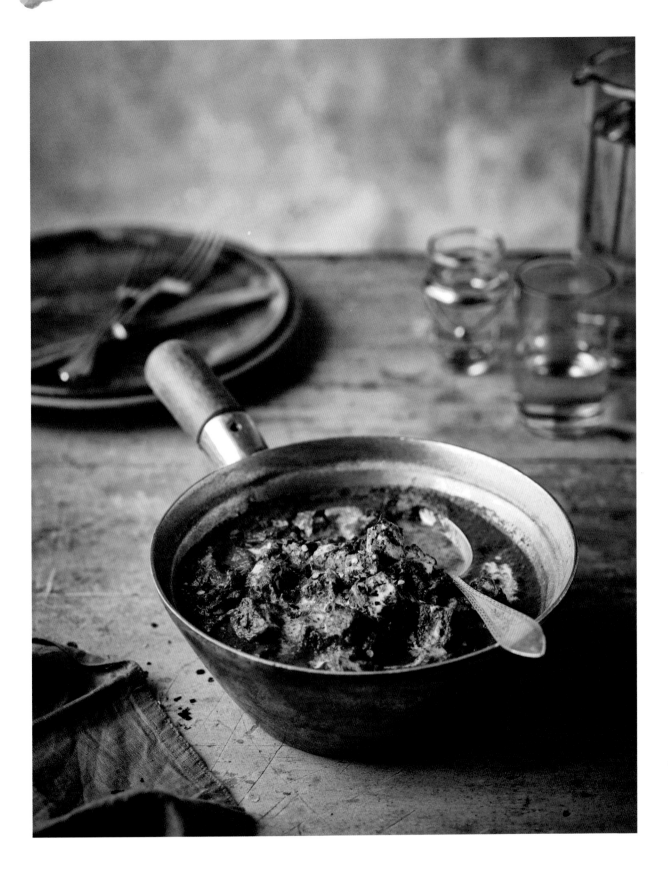

4

ways with

For me, it's the simplicity of this dish that makes it so beautiful. I loved yogurt curry throughout my childhood and, once I had the recipe from my mum, I made sure to get it absolutely right so I could make it for my own kids. They adore it too, and enjoy the variety that comes with it, because I change the colourful topping each time I serve it, depending on what is in season and what I have to hand. Serve this dish with rice.

Yogurt Curry, Four Ways

SERVES 4

250ml (9fl oz) natural yogurt
100g (3½oz) gram (chickpea) flour
1½ teaspoons salt
1½ teaspoons ground turmeric
1 teaspoon chilli powder
1.2 litres (2 pints) water
1 tablespoon sunflower oil
pinch of asafoetida
1 teaspoon mustard seeds
10 curry leaves
1 onion, finely chopped
1 teaspoon garam masala

To make the yogurt curry, combine the yogurt and gram flour in a large bowl with the salt, turmeric and chilli powder and slowly whisk in the measured water.

Heat the oil in a saucepan over medium heat. Add the asafoetida and mustard seeds. After 1–2 minutes, once they being to sizzle, stir in the curry leaves and onion and cook for 5–6 minutes, until the onion has softened.

Pour in the whisked yogurt and bring the mixture to the boil. Reduce the heat to low, cover the pan with a lid and simmer gently for 30–35 minutes or until the mixture begins to thicken.

Just before serving, sprinkle the garam masala over the curry. Transfer it to a bowl and garnish with your chosen topping (*see* pages 42–3). Serve immediately.

1 with rainbow chard
2 with roasted purple sprouting broccoli
3 with roast carrot & red onion
4 with spicy new potatoes

Yogurt Curry, Four Ways

1

with rainbow chard

1 teaspoon sunflower oil
200g (7oz) rainbow chard, roughly chopped
pinch of salt
pinch of chilli flakes

Heat the oil in a saucepan over medium heat.
Add the chopped chard and stir-fry for
4–5 minutes, until wilted. Sprinkle in the
salt and chilli and mix well.

2

with roasted purple sprouting broccoli

225g (8oz) purple sprouting broccoli
1 teaspoon sunflower oil
pinch of salt
pinch of chilli flakes
pinch of freshly ground black pepper

Preheat the oven to 180°C (350°F), Gas Mark 4.
Trim the ends off the broccoli and split any wide or
thick spears lengthways. Spread the broccoli in a single
layer on a baking tray. Drizzle over the oil and sprinkle
with the salt, chilli and pepper. Mix with your hands to
coat the broccoli well with the oil and spices. Roast for
15 minutes, turning halfway through, until the broccoli
is tender and very slightly charred.

3

with roast carrot & red onion

2 carrots, sliced into thick circles
2 red onions, cut into wedges
I teaspoon sunflower oil
pinch of salt
pinch of chilli flakes

Preheat the oven to 180°C (350°F), Gas
Mark 4. Put the carrots and onions into a
large bowl, add the oil and seasonings and
toss well to coat. Spread out the vegetables
in a single layer on a baking tray. Roast
for 15–20 minutes or until golden and
cooked through.

4

with spicy new potatoes

I teaspoon oil
10 new potatoes, thinly sliced
pinch of salt
pinch of chilli flakes

Heat the oil in a frying pan over medium heat.
Fry the sliced potatoes until golden and tender.
Sprinkle in the salt and chilli and mix well.

This is my go-to recipe when I need a quick, comforting and wonderful-tasting dish. The flavours of ghee, cumin and garlic combine to produce the perfect complement to potato. The bonus is that this dish can be enjoyed in a number of ways. It makes a brilliant accompaniment to dal and rice, and is great with the flatbread of your choice – try it in chapatti wraps, rolled up with chutney. It makes a delicious toastie filling, or you could simply serve it with some buttered toast.

Cumin Potatoes

SERVES 4

1 tablespoon ghee

1 teaspoon cumin seeds

3 garlic cloves, finely chopped

1 small green chilli, finely chopped

1 teaspoon ground turmeric

1 teaspoon chaat masala

½ teaspoon salt

5 medium potatoes, cut into 1cm (½ inch) dice

100ml (3½fl oz) water

40g (1½oz) fresh coriander, leaves and stems finely chopped

Heat the ghee in a large saucepan over medium–low heat. Add the cumin seeds and cook for 1–2 minutes, until they start to sizzle. Stir in the garlic, green chilli, turmeric, chaat masala and salt.

Stir the potatoes and the measured water into the saucepan. Cover the pan and cook over medium heat for 15–20 minutes, until the potatoes are tender.

Stir in the coriander and serve immediately.

My mum makes a dish like this with cabbage and potatoes, but I like a sabji to have more colour and texture. Carrots and peas provide both and taste brilliant with soft-cooked cabbage. You could also add beans, if you like. I serve this curry with chapatti and raita, but it also makes a great sandwich or wrap filling with some mint chutney.

Cabbage, Pea & Carrot Sabji

SERVES 4

1 tablespoon sunflower oil
1 teaspoon mustard seeds
½ teaspoon salt
½ teaspoon chaat masala
½ teaspoon chilli powder
½ teaspoon garam masala
1 cabbage, thinly sliced
200g (7oz) frozen peas
2 carrots, cut into 1cm (½ inch) dice
juice of 1 lime

Heat the oil in a saucepan over medium–low heat. When the oil is hot, add the mustard seeds and cook for 1–2 minutes, until they begin to pop, then stir in the salt and spices.

Throw in the cabbage, peas and carrots and mix well. Reduce the heat to low, cover the saucepan with a lid and cook for 20–25 minutes, until the vegetables are tender. Squeeze over the lime juice and serve immediately.

Grilling aubergine gives it a silky texture and a delicious smoky flavour that goes very well with the sweet, succulent peas in this dish. It's great served with chapatti and also as a side dish with Red Kidney Bean Curry (*see* page 91) and rice, which is one of my family's favourite combinations.

Smoky Aubergine with Peas

SERVES 4

1 large aubergine

1 tablespoon sunflower oil, plus a few drops for the aubergine

1 teaspoon mustard seeds

pinch of asafoetida

2 red onions, finely chopped

1 small green chilli, finely chopped

1 teaspoon salt

1 teaspoon garam masala

½ teaspoon chilli powder

200g (7oz) frozen peas

20g (¾oz) coriander, leaves and stems finely chopped, to garnish

Preheat the grill on the highest setting.

Rub the aubergine with a couple of drops of the oil and prick it all over with a small pointed knife or fork. Place it on a baking tray and grill it for 20 minutes, turning halfway through the cooking time, until the skin is crinkly and beginning to char. Set aside.

Heat the oil in a large saucepan over medium–low heat. Add the mustard seeds and asafoetida and cook for 1–2 minutes, until they start to sizzle, then add the onions and green chilli and cook for 10 minutes or until soft and golden.

Stir the salt, garam masala and chilli powder into the saucepan and cook for 1 minute, then mix in the frozen peas.

Peel and discard the aubergine skin and chop up the flesh finely. Stir it into the peas, then cover the pan with a lid, reduce the heat to low and cook for 10 minutes, until the mixture is thick and well amalgamated.

Take the saucepan off the heat, sprinkle over the coriander leaves and serve immediately.

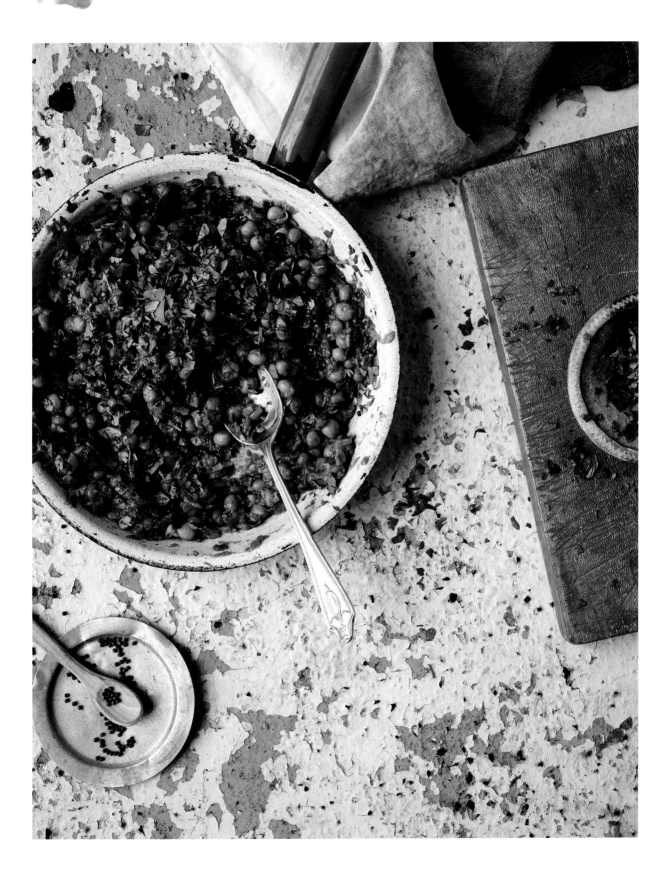

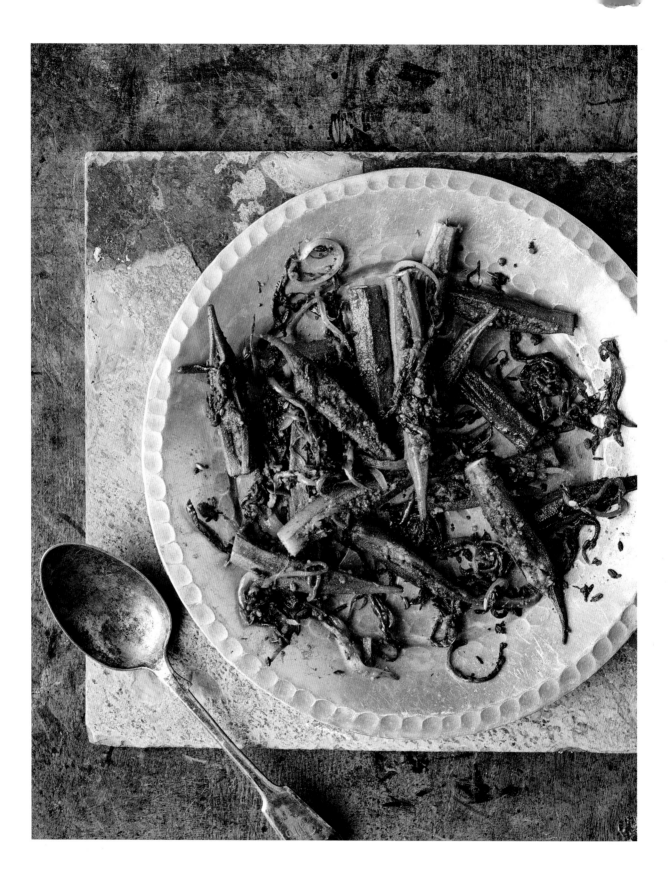

Okra is such a delicious vegetable. In this dish, its mild flavour works wonderfully with the delicately spiced gram flour filling. Stuffed okra pods make a fantastic snack and work well as a wrap filling with some salad or chutney. I tend to serve them with Tadka Dal (*see* page 92) and chapatti, which is a classic meal combination, and they work well with rice and chicken curry too.

Spicy Stuffed Okra

SERVES 4

500g (1lb 2oz) okra
1 tablespoon sunflower oil
1 teaspoon cumin seeds
1 teaspoon fennel seeds
1 large onion, thinly sliced

For the stuffing
50g (1¾oz) gram (chickpea) flour
1 tablespoon sunflower oil
1 teaspoon salt
1 teaspoon mango powder (amchur)
1 teaspoon ground cumin
1 teaspoon ground turmeric
½ teaspoon chilli powder

First, make the stuffing. In a dry frying pan, toast the gram flour over low heat for 3–4 minutes, until it starts to smoke and becomes aromatic. Add the oil and cook for another 4–5 minutes or until the flour begins to change colour.

Tip the gram flour mixture into a bowl, add the salt and spices and mix well. Set aside.

To prepare the okra pods, cut off the tops and slit them open lengthways. Fill each pod with ½ teaspoon of the stuffing mixture.

Heat the oil in a wide frying pan over medium–low heat. Add the cumin and fennel seeds and cook for 1–2 minutes, until they begin to sizzle. Stir in the stuffed okra and sliced onion, increase the heat to medium and cook for 2 minutes, then cover the pan with a lid and cook for a further 20 minutes, until the okra is tender. Serve immediately.

Stuffing peppers makes a great alternative to serving them up in a curry. In this dish, the filling is lightly spiced and has a hint of lemon that tastes wonderful when baked. Serve these with salad or with dal and rice.

Stuffed Peppers

SERVES 4

4 medium potatoes (skins on)
4 green peppers
olive oil
2 carrots, grated
2 tomatoes, grated
finely grated zest of 2 lemons
30g (1oz) fresh coriander, leaves and stems finely chopped
1 teaspoon salt
1 teaspoon ground cumin
½ teaspoon chilli powder
½ teaspoon chaat masala
1 tablespoon olive oil

Boil the potatoes in a saucepan of salted water for about 25 minutes, until tender. Drain and cool under running cold water. Once the potatoes are cool enough to handle, peel them, then grate them into a mixing bowl.

Meanwhile, preheat the oven to 180°C (350°F), Gas Mark 4.

Slice off and discard the tops of the peppers and scoop out the seeds, ensuring the cavity of each pepper is completely empty but the body remains intact. You might want to shave a thin slice from the base of each pepper to help it sit upright. Rub the outsides of the peppers with a little oil.

Add the carrots, tomatoes, lemon zest, coriander, salt and spices to the grated potatoes. Mix well, then stuff the peppers with this mixture.

Sit the filled peppers in a roasting tray and drizzle over the olive oil. Bake for 40–45 minutes, until the peppers are soft and cooked through. Serve immediately.

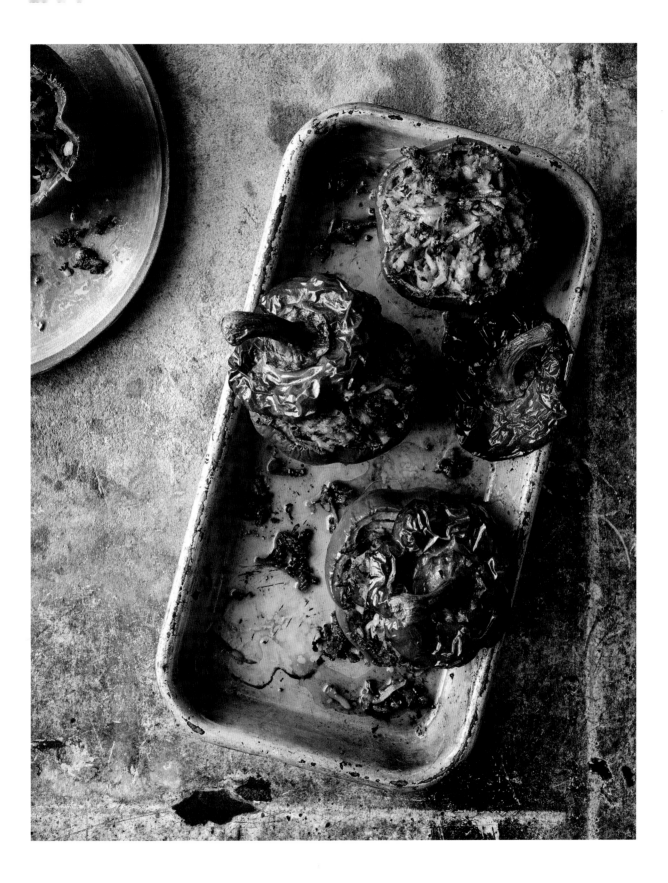

The sweet-sourness of tomatoes is the perfect foil for the enticing bitterness of dried fenugreek leaves in this super-delicious, intricately spiced curry. It's great served with rice or flatbreads such as chapatti or naan. I like to add a topping, and it's fun to vary it. I've provided three topping suggestions here, but feel free to make up your own.

Creamy Tomato & Fenugreek Curry, Three Ways

SERVES 4

1½ tablespoons sunflower oil

1 onion, roughly chopped

4 garlic cloves, roughly chopped

1cm (½ inch) piece of fresh root ginger, peeled and roughly chopped

5 tomatoes, roughly chopped

1 cinnamon stick

2 green cardamom pods

4 cloves

2 bay leaves

2 tablespoons tomato purée

200ml (⅓ pint) boiling water

2 tablespoons dried fenugreek leaves (kasuri methi)

1 teaspoon salt

1 teaspoon ground turmeric

1 teaspoon garam masala

½ teaspoon chilli powder

1 tablespoon double cream

To make the curry, heat 1 tablespoon of the oil in a saucepan and add the onion. Cook over medium heat for 5 minutes, until the onion begins to turn golden. Stir in the garlic, ginger and tomatoes and cook for 7–8 minutes, until the tomatoes are mushy.

Turn off the heat and leave to cool for 5 minutes, then use a blender to purée the mixture. Set aside.

Heat the remaining oil in another saucepan over medium–low heat. Add the cinnamon, cardamom, cloves and bay leaves and let them sizzle for 1 minute, until fragrant.

Stir in the blended tomato and onion mixture, the tomato purée and the measured boiling water. Reduce the heat to low, cover the pan with a lid and cook for 10–12 minutes, until the sauce thickens.

Stir in the fenugreek leaves, salt, turmeric, garam masala and chilli powder and cook for a further 5 minutes to incorporate the spices. To finish, stir in the cream.

To serve, pour the curry into a bowl and add the topping of your choice (*see pages 54–5*).

1 with paneer

2 with spicy cauliflower

3 with new potatoes

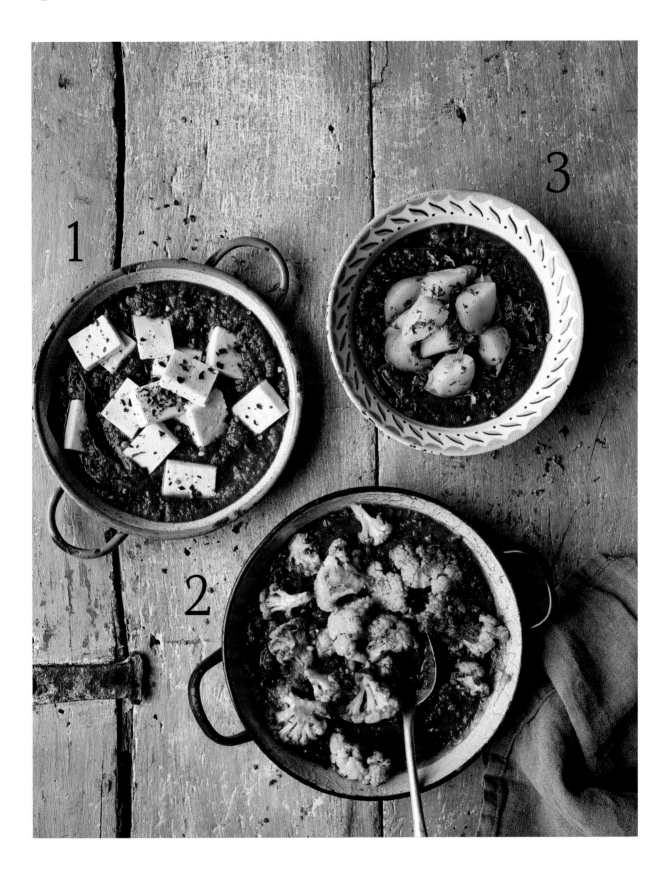

Creamy Tomato & Fenugreek Curry, Three Ways

1

with paneer

250g (9oz) paneer
pinch of chilli flakes

Soak the block of paneer in a bowl of warm water for 5–7 minutes.
Remove it from the water and pat dry. Cut it into small rectangles.
Sprinkle with the chilli flakes.

2

with spicy cauliflower

½ cauliflower, cut into small florets
¼ teaspoon ground turmeric
¼ teaspoon ground cumin
pinch of salt
1 teaspoon sunflower oil
1 green chilli, thinly sliced

Preheat the oven to 180°C (350°F), Gas Mark 4.
Spread out the cauliflower florets on a baking
sheet and sprinkle over the turmeric, cumin,
salt and oil. Mix well with your hands. Roast
for 15–20 minutes, until the cauliflower is
tender. Sprinkle with the sliced chilli.

3

with new potatoes

400g (14oz) baby new potatoes (skins on), halved
½ teaspoon salt
1 tablespoon dried fenugreek leaves
(kasuri methi), to garnish

Put the potatoes into a saucepan of water
and add the salt. Simmer for 7–8 minutes,
until the potatoes are tender. Drain and
leave to steam dry. Garnish with the
dried fenugreek leaves.

This dish has a lovely sweetness to it that balances very well with the spices used. Yogurt adds creaminess, and a flourish of coriander at the end adds a lively fresh note. Serve this curry with rice, chapatti or some bread.

Sweet Potato Yogurt Curry

SERVES 4

1 tablespoon sunflower oil
1 teaspoon cumin seeds
pinch of asafoetida
1 onion, roughly chopped
2 garlic cloves, finely chopped
2 tomatoes, roughly chopped
½ teaspoon salt
½ teaspoon chilli powder
½ teaspoon ground cumin
½ teaspoon ground coriander
1 teaspoon medium curry powder
100ml (3½fl oz) natural yogurt, at room temperature
1 sweet potato, roughly 500g (1lb 2oz), cut into 2.5cm (1 inch) dice
100ml (3½fl oz) boiling water
40g (1½oz) fresh coriander, leaves and stems finely chopped

Heat the oil in a saucepan over low heat. Add the cumin seeds and asafoetida and, after 1–2 minutes, once they begin to sizzle, stir in the onion. Cook for 5 minutes, until the onion begins to colour. Now mix in the garlic and cook for another minute.

Stir the tomatoes into the saucepan. Cook over low heat for 5 minutes, until softened. Now mix in the salt and all the spices and cook for another minute. Add the yogurt and stir continuously for 2 minutes, until the yogurt has heated through – constant stirring will prevent it from splitting.

Now add the sweet potato to the saucepan, mix well, then stir in the measured boiling water. Ensure that everything is combined, cover the pan with a lid and cook over low heat for 20 minutes, until the potato is cooked through. Sprinkle over the coriander and serve immediately.

The lovely earthy flavour of chestnut mushrooms works well with creamy paneer and red onions in this tasty dish. It is quick to make, so is the ideal midweek meal. Serve it with Pearl Millet & Potato Flatbreads (*see* page 158), or rolled up in chapatti with some chutney. Any leftovers will make a great packed lunch the next day.

Mushroom Paneer

SERVES 4

1 tablespoon sunflower oil

1 tablespoon salted butter

1 teaspoon cumin seeds

2 red onions, finely chopped

250g (9oz) chestnut mushrooms, finely chopped

2.5cm (1 inch) piece of fresh root ginger, peeled and grated

250g (9oz) paneer

2 tomatoes, finely chopped

¾ teaspoon salt

½ teaspoon chilli powder

½ teaspoon ground cumin

½ teaspoon ground turmeric

½ teaspoon garam masala

1 tablespoon double cream

handful of fresh coriander leaves, finely chopped, to garnish

Heat the oil and butter in a large saucepan set over medium heat. Add the cumin seeds and, after 1–2 minutes, when they begin to sizzle, stir in the onions and cook for 3–4 minutes, until they start to soften. Mix in the mushrooms and ginger and cook for 5 minutes, until the mushrooms are soft and the onions are golden.

Meanwhile, soak the block of paneer in warm water for 5 minutes, then grate it. Set aside.

Add the chopped tomatoes to the mushroom mixture, then reduce the heat to low, cover the pan with a lid and cook for 5 minutes, until the tomatoes have softened.

Stir in the salt and spices. Now add the grated paneer, increase the heat to medium and cook, stirring, for 2–3 minutes, until everything is well combined.

Pour in the cream, stir well and cook for a few seconds to finish. Sprinkle with the coriander before serving.

This simple veggie dish really packs in the colours and spices. The base curry, full of lip-smacking flavour, provides a good vehicle for the stir-fried peppers. Adding smooth, creamy paneer takes the combination to another level of deliciousness. Serve this dish with rice or chapatti.

Cumin Pepper & Paneer

SERVES 4

2 onions

2 tablespoons sunflower oil

2 garlic cloves, thinly sliced

2 tomatoes

1 red pepper, cored, deseeded and halved

1 yellow pepper, cored, deseeded and halved

2 tablespoons tomato purée

200ml (⅓ pint) boiling water

250g (9oz) paneer

1¼ teaspoons salt

1 teaspoon ground cumin

½ teaspoon chilli powder

1 tablespoon chilli sauce

1 teaspoon honey

1 teaspoon cumin seeds

2.5cm (1 inch) piece of fresh root ginger, peeled and julienned

1 green pepper, cored, deseeded and thinly sliced

Blitz 1 of the onions to a paste in a mini food processor. Heat 1 tablespoon of the oil in a large saucepan, then add the onion paste and cook over medium–low heat for 6–7 minutes or until the onion turns golden. Add the garlic and cook for another 2 minutes, until the garlic begins to colour.

Using a blender, blitz the tomatoes, half the red pepper and half the yellow pepper to a paste. Stir this mixture into the onion paste in the saucepan along with the tomato purée and the measured boiling water. Cover the pan with a lid, increase the heat to medium and cook for 15–20 minutes, until the tomato is cooked and the sauce thickens slightly.

Meanwhile, soak the block of paneer in a bowl of warm water for 5 minutes, then remove it and slice it into thin rectangles. Set aside.

Add the salt, ground cumin, chilli powder, chilli sauce and honey to the saucepan and mix well. Cover the pan with a lid, take it off the heat and set aside.

Thinly slice the remaining onion and red and yellow pepper halves, to match your green pepper slices.

Heat the remaining oil in a separate saucepan over medium heat. Add the cumin seeds and cook for 1–2 minutes, until they begin to sizzle. Increase the heat to high, stir in the sliced onion and stir-fry for 2 minutes, then add the ginger and the sliced peppers and stir-fry for 2 minutes, until the peppers are cooked through.

Tip the stir-fried vegetables into the tomato sauce and add the slices of paneer. Allow to heat through, mixing gently, then serve immediately.

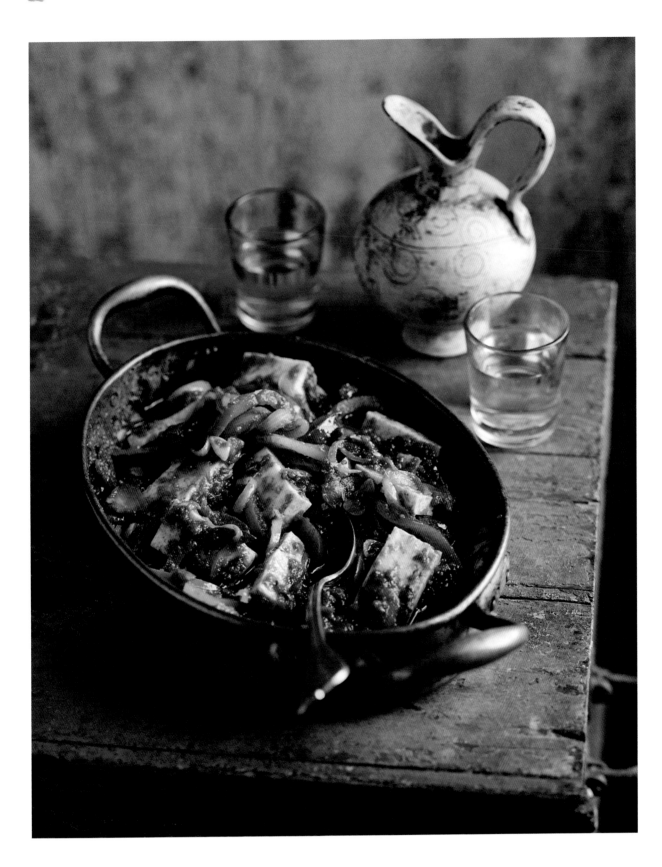

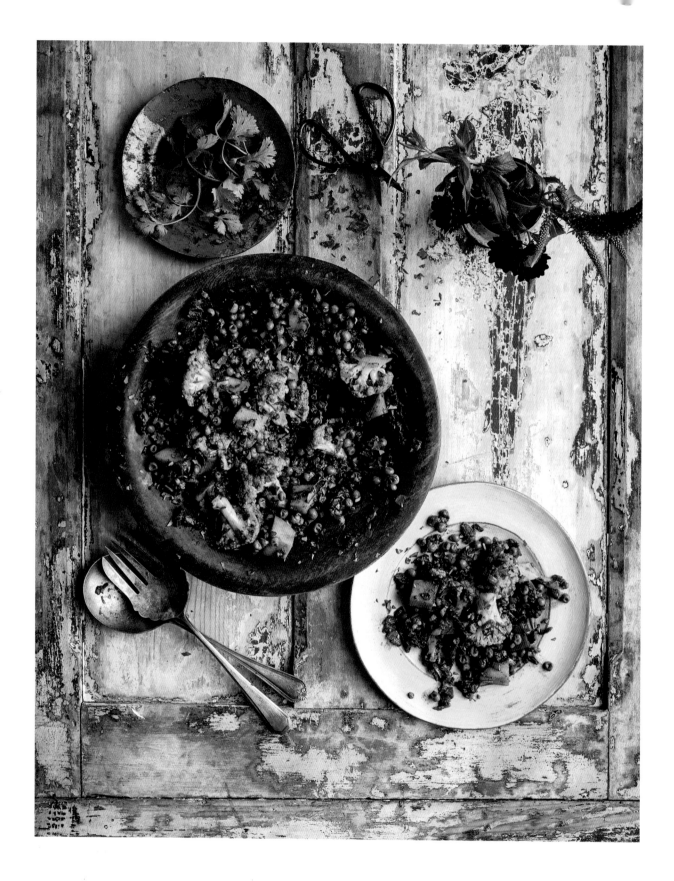

This simple yet absolutely delightful mix of cauliflower and potatoes was a particularly popular dish at my mother's kitchen table. We often had it with dal and rice, but I also loved it with *lachcha paratha*, which Mum always made with homemade ghee. Try it in a wrap or sandwich with chutney or ketchup and some salad.

Masala Cauliflower Potatoes

SERVES 4

1 tablespoon sunflower oil

1 teaspoon mustard seeds

1 teaspoon cumin seeds

1 large onion, roughly chopped

2 garlic cloves, finely chopped

1cm (½ inch) piece of fresh root ginger, peeled and finely chopped

1 small green chilli, finely chopped

2 tomatoes, roughly chopped

1 teaspoon salt

1 teaspoon garam masala

1 teaspoon ground turmeric

½ teaspoon chilli powder

200g (7oz) frozen peas

1 cauliflower, cut into small florets

1 large potato, cut into 2.5cm (1 inch) dice

50ml (2fl oz) water

handful of fresh coriander leaves, finely chopped, to garnish

Heat the oil in a large saucepan over medium–low heat. Add the mustard and cumin seeds and cook for 1–2 minutes, until they begin to sizzle. Stir in the onion and cook for 10–12 minutes or until golden.

Mix the garlic, ginger and chilli into the saucepan and cook for 2 minutes, then stir in the tomatoes, salt and spices. Increase the heat to high and cook for 2 minutes.

Stir in the peas, cauliflower, potato and measured water. Cover the pan with a lid, reduce the heat to low and cook for 20–25 minutes, until the cauliflower and potato are tender.

Take the pan off the heat, sprinkle over the coriander and serve hot.

Bitter gourd is one of those vegetables that you either love or hate. In my case, I love it, but it does depend on how it is cooked. For this dish, I use a very simple spice stuffing, and I cook the bitter gourd with lots of red onion. Marinating it in salt prior to cooking eliminates a lot of its natural bitterness and allows it to soak up all the spice flavours. Serve this sabji with chapatti or alongside dal and rice.

Spicy Bitter Gourd with Onions

SERVES 4

500g (1lb 2oz) bitter gourds (karela)
1 tablespoon salt
2 tablespoons sunflower oil
3 red onions, thinly sliced

For the stuffing

1 teaspoon ground turmeric
½ teaspoon chilli powder
1 teaspoon ground cumin
1 teaspoon chaat masala
½ teaspoon caster sugar
¼ teaspoon salt

Peel the gourds. Slit open each piece along the length on one side so you can see all the seeds. Rub the salt into the insides and outsides of the gourds. Set aside for 1 hour.

To make the stuffing, combine all the ingredients in a small bowl and mix well.

Rinse the gourd pieces inside and out to wash off the salt. Pat them dry with kitchen paper. Take roughly ½ teaspoon of the spice mix and use it to stuff each piece of gourd through the slit.

Heat the oil in a large saucepan over high heat. Add the stuffed gourd and cook for 5 minutes, until it begins to colour. Stir in the onions, reduce the heat to low and cook for 35–40 minutes, until the gourd is tender. Serve immediately.

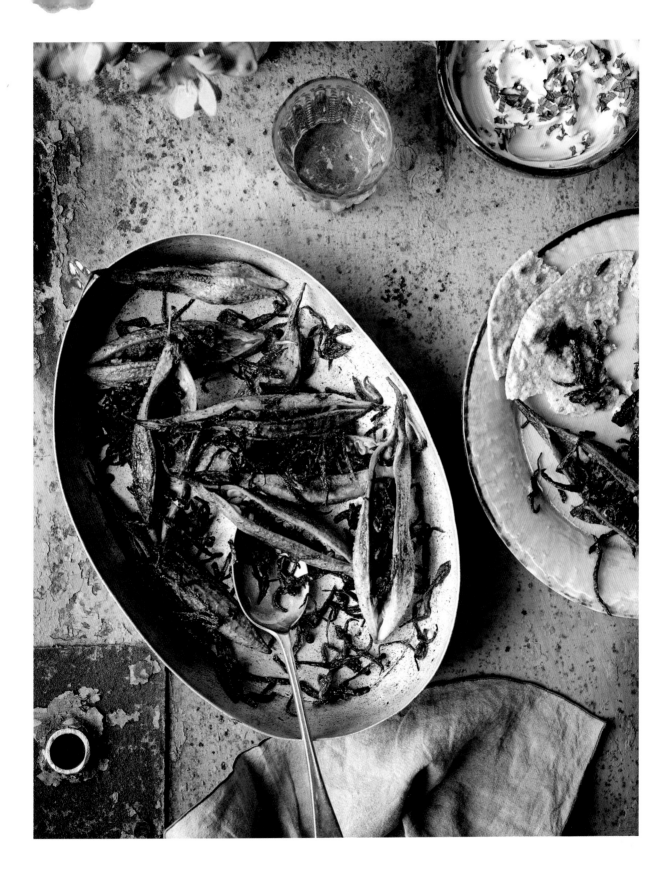

If you're thinking that this sounds like an unusual combination then, yes, you are definitely right. But it is one that works a treat. The earthiness of the broccoli goes well with soft, spice-infused paneer. This dish is great served with chapatti, or in a wrap with some spicy chutney, or as a side dish with lentils and rice.

Paneer & Purple Sprouting Broccoli Sabji

SERVES 4

1 tablespoon sunflower oil

1 teaspoon mustard seeds

10 curry leaves

2 red onions, finely chopped

225g (8oz) paneer, cut into 1cm (½ inch) dice

225g (8oz) purple sprouting broccoli, cut into small chunks

½ teaspoon salt

½ teaspoon ground turmeric

½ teaspoon chilli powder

½ teaspoon mango powder (amchur)

50ml (2fl oz) boiling water

Heat the oil in a saucepan over low heat. Add the mustard seeds and let them sizzle for a few seconds, then mix in the curry leaves and onions and cook over low heat for 5 minutes, until the onions have softened.

Meanwhile, soak the paneer cubes in a bowl of hot water for a minimum of 5 minutes.

Stir the broccoli, salt, turmeric, chilli powder, mango powder and the measured boiling water (which will create a little steam) into the saucepan. Cover the pan with a lid and cook over low heat for 5–6 minutes or until the broccoli has softened slightly.

Drain the paneer and add it to the saucepan, mixing well. Increase the heat to high and cook for 1 minute, then serve immediately.

The humble potato shines through in this dish, with a little help from green chillies and fresh coriander. They give the soup not only a beautiful colour, but also a lovely dose of tangy heat.

Potato & Coriander Soup

SERVES 4

1 tablespoon sunflower oil

1 tablespoon salted butter

4 garlic cloves, roughly chopped

1 small green chilli, finely chopped

2 leeks, finely chopped

3 carrots, cut into 1cm (½ inch) pieces

3 medium potatoes, peeled and cut into 1cm (½ inch) pieces

2 vegetable stock cubes

850ml (1½ pints) boiling water

50g (1¾oz) fresh coriander, leaves and stems roughly chopped

¼ teaspoon salt

¼ teaspoon freshly ground black pepper

¼ teaspoon chilli flakes

Heat the oil and butter together in a large saucepan over medium–low heat. Add the garlic and chilli and cook for 2 minutes, until they begin to colour and soften. Mix in the leeks and cook for roughly 5 minutes, until softened.

Stir the carrots and potatoes into the saucepan, increase the heat to medium and cook for 5 minutes, stirring occasionally, until they begin to soften.

Crumble the stock cubes into the saucepan and add the measured boiling water. Set aside some of the coriander for garnish and stir the remainder into the saucepan. Cover the saucepan with a lid and cook for 15–20 minutes, until the potatoes are very tender.

Take the saucepan off the heat, then purée the soup using a hand-held blender. Return the pan to the hob and cook for a final 2 minutes, then stir in the salt, pepper and chilli flakes. Serve sprinkled with the reserved chopped coriander.

Soft, spicy gram flour dumplings soak up all the lovely sour and spicy juices in this amazing tomato curry. Please don't be put off by the length of the ingredients list here – it's not a difficult recipe, it just requires a little more effort than others in this book. But I promise that the results are worth it – this dish is a total joy to eat. Serve it with chapatti or rice.

Gram Flour Dumplings in Tomato Curry

SERVES 2

For the gram flour dumpling dough

125g (4½oz) gram (chickpea) flour

¼ teaspoon cumin seeds

¼ teaspoon coriander seeds, lightly crushed

¼ teaspoon fennel seeds

¼ teaspoon dried fenugreek leaves (kasuri methi)

pinch of asafoetida

¼ teaspoon chilli powder

¼ teaspoon ground turmeric

¼ teaspoon salt

1 tablespoon natural yogurt

½ teaspoon sunflower oil

roughly 3 tablespoons water

Before you start cooking, put the cashew nuts for the curry into a small bowl with the milk and leave to soak for 1 hour.

To make the dumplings, combine all the ingredients, except the water, in a bowl and mix well. Gradually add just enough of the measured water to bring it all together into a dough – you might not need all the water or you may need a little more, so add just a few drops at a time to ensure the dough is smooth but not sticky. Knead the dough for a few seconds, then divide it into 2 equal pieces. Roll each piece into a sausage shape roughly 15cm (6 inches) long and 2.5cm (1 inch) wide.

To cook the dumplings, bring the measured water to the boil in a large saucepan. Carefully drop the sausage-shaped rolls into the water. Simmer over medium heat for 10–12 minutes, until the rolls float to the surface of the water, which means they are cooked. Remove them carefully with a slotted spoon and transfer to a chopping board. Slice the rolls into discs with a thickness of 5mm (¼ inch). These are your dumplings.

For cooking the gram flour dumplings

850ml (1½ pints) water

1 teaspoon sunflower oil

¼ teaspoon black mustard seeds

For the curry

25g (1oz) cashew nuts

4 tablespoons milk

400g (14oz) can chopped tomatoes

1 tablespoon ghee

pinch of asafoetida

1 small green chilli, finely chopped

½ teaspoon cumin seeds

½ teaspoon coriander seeds, lightly crushed

½ teaspoon fennel seeds

1cm (½ inch) piece of fresh root ginger, peeled and julienned

150ml (¼ pint) natural yogurt

½ teaspoon salt

½ teaspoon chilli powder

½ teaspoon ground turmeric

1 teaspoon garam masala

1 tablespoon dried fenugreek leaves (kasuri methi)

¼ teaspoon honey

Next, fry the dumplings. Heat the oil in a wide frying pan over medium–low heat. Add the mustard seeds and cook for a few seconds, until they start to sizzle. Add the dumplings. Cook for 2 minutes, turning once so they are golden on both sides. Transfer the dumplings to a plate and cover them closely so they remain soft and do not dry out.

To make the curry, put the soaked cashews, milk and canned tomatoes into the jug of a blender and blitz until smooth. Set aside.

Heat the ghee in a saucepan over medium–low heat. Add the asafoetida and let it sizzle for a few seconds, then stir in the green chilli, cumin, coriander and fennel seeds. Let them sizzle away for a few seconds, then mix in the ginger.

In a small bowl, mix together the yogurt, salt, chilli powder, turmeric and garam masala. Reduce the heat under the saucepan to low, then add the yogurt mixture, stirring continuously for a full minute so that the yogurt does not split.

Now pour the tomato, milk and cashew nut mixture into the saucepan and mix well. Cover the pan with a lid and cook over low heat for 25–30 minutes, until the sauce has thickened slightly.

Lastly, stir the fenugreek leaves, honey and fried dumplings into the tomato curry and mix well. Serve immediately.

Although the sauce in this dish contains many spices, they work in harmony to create a result that is delicate, smooth and totally delicious. It works amazingly well with eggs, but is equally good with chicken, fish or potatoes – each one adds its own flavour to the sauce, so it tastes different each time. Serve this dish hot with rice or chapatti.

Cashew & Tomato Curry, Four Ways

SERVES 4

1 tablespoon sunflower oil

1 cinnamon stick

2 green cardamom pods

4 cloves

2 bay leaves

2 red onions, finely chopped

2 garlic cloves, grated

1cm (½ inch) piece of fresh root ginger, peeled and grated

200ml (⅓ pint) boiling water

1 teaspoon salt

1 teaspoon garam masala

1 teaspoon ground coriander

½ teaspoon chilli powder

1 tablespoon double cream

For the cashew and tomato paste

1 teaspoon sunflower oil

15 cashew nuts

4 tomatoes, roughly chopped

2 tablespoons tomato purée

1 small green chilli, roughly chopped

First, make the cashew and tomato paste. Heat the oil in a medium saucepan over medium heat. Add the remaining paste ingredients and cook for 10 minutes, until the tomatoes have softened. Leave to cool for 5 minutes, then use a mini food processor to blitz the mixture until smooth. Set aside.

To make the curry sauce, heat the oil in a large saucepan over medium heat. Add the cinnamon stick, cardamom pods, cloves and bay leaves and cook for a few seconds. Throw in the onions and cook for 8–10 minutes, until the onions are golden. Stir in the garlic and ginger and cook for another minute.

Now add the tomato and cashew paste to the saucepan along with the measured boiling water and mix well. Cover the pan with a lid, reduce the heat to low and cook for 15 minutes to allow all the flavours come together.

Once the cooking time has elapsed, stir in the salt, garam masala, ground coriander, chilli powder and cream, then keep the mixture warm until your chosen addition (*see* pages 72–3) is ready to add to it.

1 with eggs

2 with chicken

3 with fish

4 with potatoes

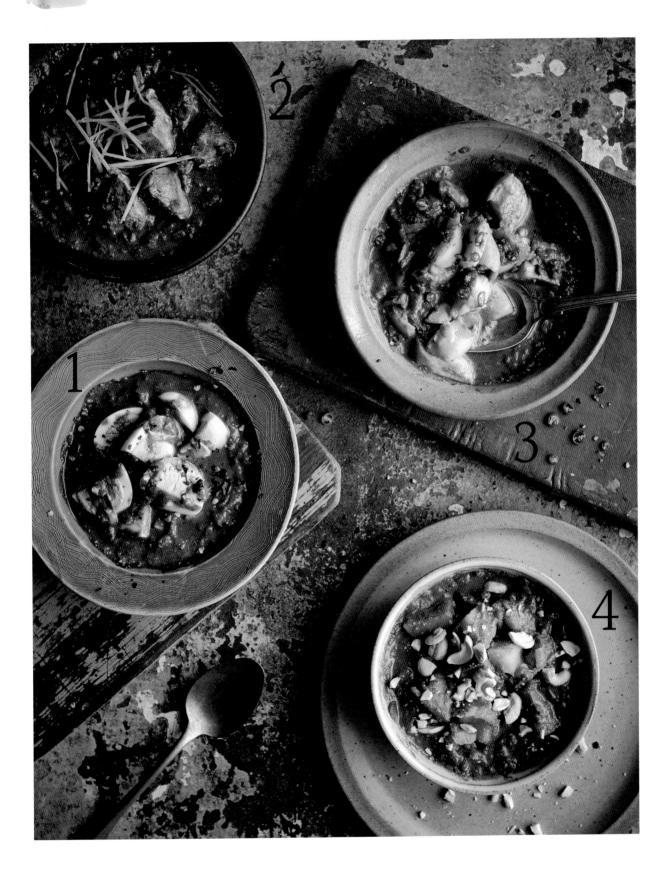

Cashew & Tomato Curry, Four Ways

1

with eggs

8 eggs
¼ teaspoon chilli flakes, to garnish

Boil the eggs for 12 minutes. Cool under the cold tap, then shell and quarter them. Gently add the egg quarters to the curry sauce and cook for 1 minute, then serve immediately, garnished with chilli flakes.

2

with chicken

600g (1lb 5oz) skinless chicken breast fillets, cut into 2.5cm (1 inch) pieces
shredded ginger, to garnish

Once the curry sauce is ready, add the chicken to the saucepan, cover the pan with a lid and cook for 15 minutes or until the chicken is tender and cooked through. Serve immediately, garnished with shredded ginger.

3

with fish

600g (1lb 5oz) cod fillets,
cut into 2.5cm (1 inch) dice
sliced green chilli, to garnish

Once the curry sauce is ready, add the
fish chunks to the saucepan, cover the
pan with a lid and cook for 5 minutes
or until the fish is cooked through.
Serve immediately, garnished with
sliced green chilli.

4

with potatoes

4 medium potatoes, peeled
handful of cashew nuts, roughly chopped, to garnish

Boil the potatoes in salted water until
tender. Drain the potatoes and set aside
until cool enough to handle, then cut
them into 2.5cm (1 inch) dice. Once the
curry is ready, add the potatoes, then
cover the saucepan with a lid and cook
for 2 minutes to finish. Serve immediately,
garnished with chopped cashew nuts.

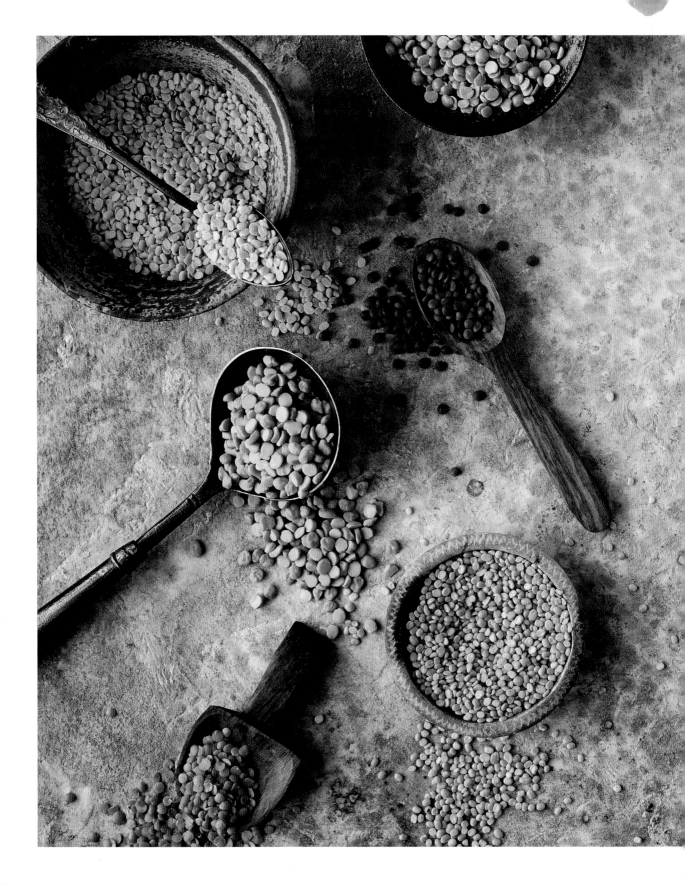

Butternut Squash, Chickpea & Spinach Soup

Five Lentils

Spicy Chickpeas, Four Ways

Black Lentils with Red Kidney Beans

Chana Dal with Roasted Aubergine

Red Lentils with Spinach

Red Kidney Bean Curry

Tadka Dal, Three Ways

Barley with Vegetables & Peanuts

Black Eyed Beans with Cavolo Nero

Butternut Squash with Red Lentils & Tamarind

Chana Dal with Okra & Coconut

Masala Black Chickpeas

Beetroot Sabji with Moong Dal

Sprouted Moong Sabji

Lentils & Grains

This hearty soup, with a dollop of natural yogurt on top, will fill you up, but you can serve it over rice if you prefer. The simple flavours come together really well, thanks to the spicing.

Butternut Squash, Chickpea & Spinach Soup

SERVES 4

1 butternut squash, peeled and cut into 2.5cm (1 inch) dice

1 tablespoon plus 1 teaspoon sunflower oil

1¼ teaspoons salt

1 onion, finely chopped

1 teaspoon ground cinnamon

1 teaspoon ground cumin

½ teaspoon chilli powder

400g (14oz) can chopped tomatoes

400g (14oz) can chickpeas

400ml (14fl oz) boiling water

100g (3½oz) spinach leaves, finely chopped

Preheat the oven to 180°C (350°C fan), Gas Mark 4.

Spread out the squash pieces on a roasting tray. Sprinkle over 1 teaspoon of the oil and ¼ teaspoon of the salt, then rub the oil over the cubes with your fingers. Bake for 40 minutes, until the squash is soft and starting to brown.

Meanwhile, heat the remaining oil in a large saucepan over medium–low heat. Add the onion and cook for 5–7 minutes, until it begins to colour.

Add the remaining salt to the saucepan, along with the cinnamon, cumin and chilli powder, and mix well. Next, tip in the canned tomatoes, the chickpeas (along with the canning water) and the measured boiling water. Give everything a good stir, then cover the pan with a lid, reduce the heat to low and cook for 30 minutes, until everything is cooked down and well combined.

Stir the roasted squash and spinach leaves into the saucepan. Cover the pan with the lid and cook for a further 10 minutes, until the spinach has wilted. Serve immediately.

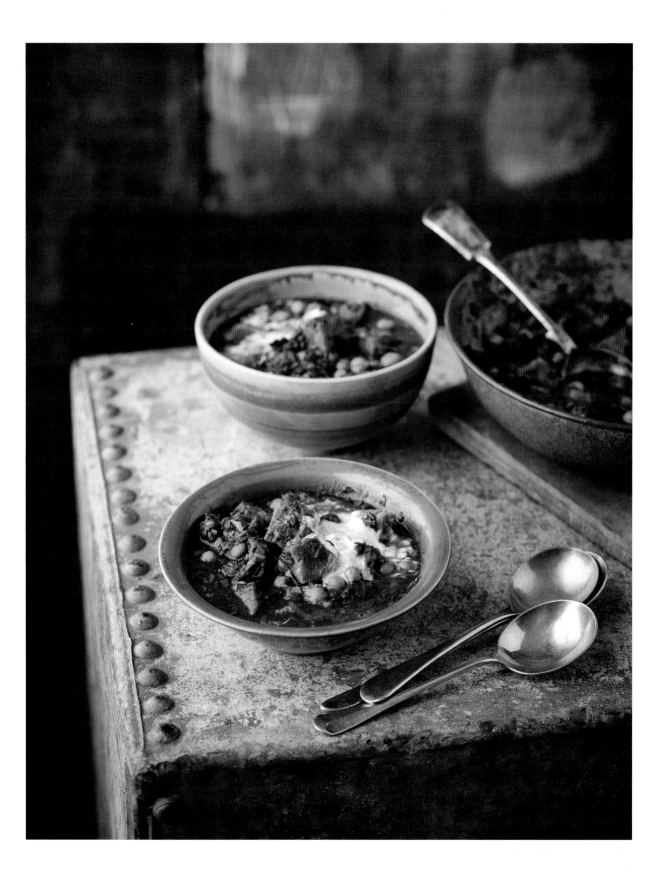

Each lentil variety in this extraordinary dish brings its unique flavour, but feel free to skip one or two if you don't have them all to hand – simply increase the quantities of the others to fill the gap. The dish is deceptively simple to make. It is the tempering (adding fried spices, onion, chilli and other flavourings at the end of cooking) that gives it an impressive colour boost and flavour kick. Serve the dal with rice or chapatti.

Five Lentils

SERVES 4

100g (3½oz) split yellow moong lentils (moong dal)

100g (3½oz) split chickpeas (chana dal)

100g (3½oz) whole green mung beans (moong sabut)

50g (1¾oz) split black lentils (urad dal)

50g (1¾oz) split pigeon peas (toor dal)

500ml (18fl oz) cold water, for soaking

1 teaspoon salt

500ml (18fl oz) boiling water

1 tablespoon chopped coriander, to garnish (optional)

For the tempering

1 tablespoon ghee

pinch of asafoetida

2.5cm (1 inch) piece of fresh root ginger, peeled and julienned

1 onion, thinly sliced

1 small green chilli, thinly sliced

1 tomato, thinly sliced

½ teaspoon chilli powder

½ teaspoon ground cumin

½ teaspoon mango powder (amchur)

½ teaspoon salt

Soak all the lentils together in the measured soaking water in a deep saucepan for 2–3 hours. When they have swollen, transfer the pan to the hob, stir in the salt and bring the mixture to the boil. Once boiling, half-cover the pan with a lid, reduce the heat to low and simmer for 30 minutes. Once the cooking time has elapsed, add the measured boiling water to the pan and continue to cook for 30 minutes or until the lentils are soft.

Heat the ghee in a saucepan over medium heat. Add the asafoetida. After a minute or so, when it starts to sizzle and smells fragrant, mix in the ginger and cook for 1 minute. Next, stir in the onion and chilli and cook for 4–5 minutes, until the onion is soft.

Stir the tomato slices into the onion mixture and cook for 2 minutes, until they just begin to soften. Now add the chilli powder, cumin, mango powder and salt, mix well and cook for 1 minute more.

Pour the lentils into a deep serving bowl and spoon the onion mixture over the top. Garnish with chopped coriander, if liked, and serve warm.

ways with

Spicy in terms of both heat and flavour, these delicious chickpeas provide a wonderful base for fish in particular. I love them so much that if we don't have any sea bass, I'll top them with some simple cooked veg or spiced yogurt with a little Bombay mix scattered over. They are also great served with rice or bread.

Spicy Chickpeas, Four Ways

SERVES 2

1 tablespoon sunflower oil
1 teaspoon mustard seeds
1 large red onion, finely chopped
1 small green chilli, finely chopped
2 tablespoons tomato purée
1 teaspoon salt
½ teaspoon chilli flakes
½ teaspoon ground turmeric
½ teaspoon garam masala
400g (14oz) can chickpeas
40g (1½oz) dill, finely chopped

Heat the oil in a large saucepan over medium–low heat. Add the mustard seeds and cook for 1–2 minutes, until they begin to sizzle. Now mix in the onion and green chilli, then cook for about 10 minutes, until the onion becomes golden. Stir in the tomato purée, reduce the heat to low and cook for 5 minutes, until the tomato purée is cooked.

Stir the salt, chilli flakes, turmeric and garam masala into the saucepan and cook for 2 minutes. Next, add the chickpeas along with the canning water. Mix well, cover the saucepan with a lid and cook for 10–15 minutes, until the flavours are well combined.

Meanwhile, prepare your preferred topping (*see* pages 82–3).

When the cooking time has elapsed, add the dill and mix well. To serve, pile the chickpeas on to 2 plates and lay the topping of your choice on top.

1 with sea bass
2 with green beans
3 with roasted beetroot
4 with yogurt

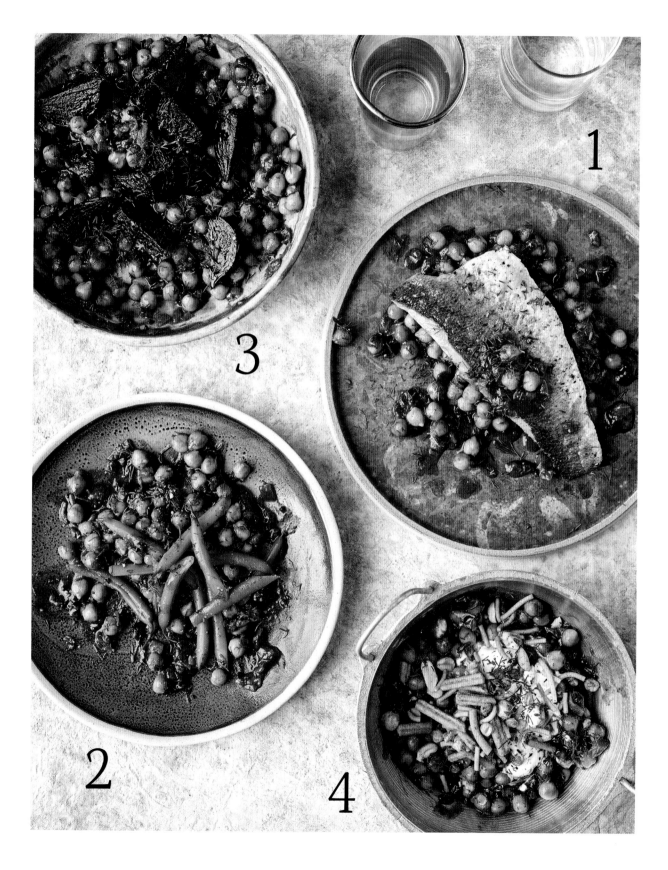

Spicy Chickpeas, Four Ways

1

with sea bass

2 sea bass fillets
pinch of salt
pinch of freshly ground black pepper
1 teaspoon sunflower oil

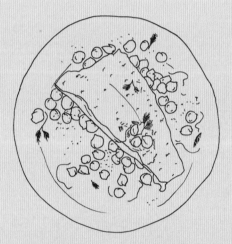

Sprinkle the fish fillets with salt and pepper. Heat a frying pan over medium heat and add the oil. Lay the sea bass in the pan with the skin sides facing down and immediately press down on the fillets to prevent them curling up. Cook the fish for 3–4 minutes undisturbed – they should be almost cooked through and the skin will be crisp and brown. Flip them over and fry on the flesh side for 2 minutes, or until just done.

2

with green beans

15–16 fine green beans, halved
pinch of salt
pinch of freshly ground black pepper

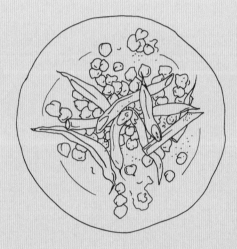

Boil some water in a saucepan and add the beans. Cook for 3–4 minutes, until the beans are tender but still have some bite. Drain the beans and put them into a bowl. Sprinkle over the salt and pepper and mix gently.

3

with roasted beetroot

2 small beetroot, peeled and quartered
pinch of salt
pinch of freshly ground black pepper
½ teaspoon olive oil

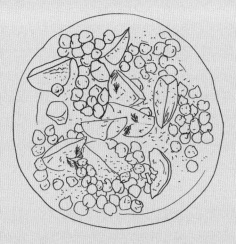

Preheat the oven to 180°C (350°F), Gas Mark 4.
Put the quartered beetroot into a small roasting
tray, sprinkle over salt and pepper and drizzle
with oil. Roast for 20 minutes or until the edges
of the beetroot are becoming crisp.

4

with yogurt

4 tablespoons natural yogurt
pinch of salt
pinch of ground cumin
handful of Bombay mix

Put the yogurt into a bowl with the salt
and cumin and mix well. Sprinkle over
the Bombay mix.

My kids tell me this is one of their favourite lentil dishes. Cooking it with love, slowly over a low heat, brings out the flavour of the black lentils and black cardamom and results in a rich, intense, deep taste. And the best part is that it tastes even better the next day, so be sure to make a little extra. Serve it with rice, naan or chapatti.

Black Lentils with Red Kidney Beans

SERVES 4–6

300g (10½oz) whole black lentils (urad dal)

100g (3½oz) dried red kidney beans

roughly 500ml (18fl oz) water, for soaking

1.4 litres (2½ pints) water

1½ teaspoons salt

4 black cardamom pods

1 tablespoon ghee

4 garlic cloves, finely chopped

1 small green chilli, finely chopped

2 tablespoons tomato purée

1 tablespoon garam masala

1 teaspoon chilli powder

100–200ml (3½–7fl oz) boiling water, to loosen, if required

1 tablespoon double cream

rice, naan or chapatti, to serve

To garnish

1 tablespoon chopped coriander

1 small green chilli, thinly sliced

Soak the lentils and beans in the measured soaking water for 4–5 hours.

Transfer the pulses and their soaking water to a deep saucepan and add the measured water, plus the salt and black cardamom pods. Bring the liquid to the boil, then cover the pan with a lid and simmer over low heat for 1 hour or until the lentils and beans are cooked.

In a separate large saucepan, heat the ghee over low heat, then add the garlic and chilli and cook for 1 minute. Stir in the tomato purée, garam masala and chilli powder and cook for another minute.

Tip the cooked lentils and beans into the pan of spices, mixing well. Cover the pan with a lid and cook over low heat for 1–1½ hours, stirring every 10–15 minutes to ensure the mixture does not stick to the base of the pan. If the lentils become too thick during cooking, add just enough of the measured boiling water to loosen the mixture.

Finally, when the dal is ready, add the cream and mix well. Garnish with the coriander and sliced chilli and serve immediately with rice, naan or chapatti.

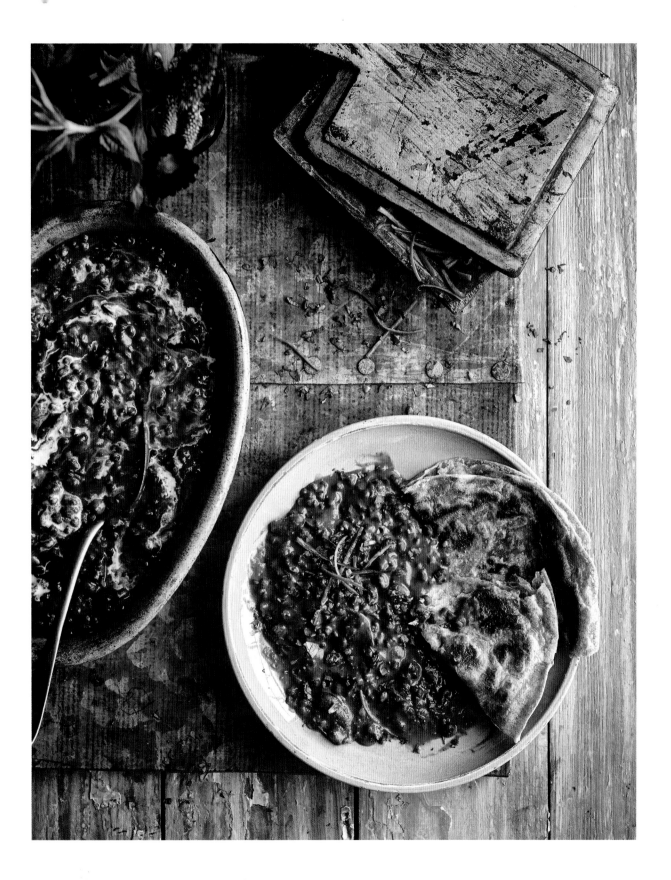

Little roasted aubergine bites, slightly crispy on the outside but soft and smoky inside, pair perfectly with chana dal, a comparatively rich and heavy lentil. This dish needs no strong spices – both the dal and aubergine are full of flavour, and the curry leaves season it perfectly. Serve it with rice or chapatti.

Chana Dal with Roasted Aubergine

SERVES 4

1 large aubergine, cut into 2cm (¾ inch) dice

1¼ teaspoons salt

¼ teaspoon chilli powder

1 tablespoon plus 1 teaspoon sunflower oil

1 teaspoon mustard seeds

10 curry leaves

1 red onion, finely chopped

300g (10½oz) split chickpeas (chana dal)

1 teaspoon ground turmeric

1.2 litres (2 pints) water

Preheat the oven to 180°C (350°F), Gas Mark 4.

Spread out the aubergine pieces on a roasting tray. Sprinkle over ¼ teaspoon of the salt, the chilli powder and 1 teaspoon of the oil, then mix with your hands to ensure the aubergine pieces are well coated. Roast for about 15 minutes, until the aubergine is soft. Set aside.

Heat the remaining oil in a large saucepan over medium heat. Add the mustard seeds and curry leaves and let them sizzle for a few seconds, then stir in the onion. Cook for 5–6 minutes, until the onion begins to colour.

Now stir in the split chickpeas, remaining salt, turmeric and measured water. Bring the mixture to the boil, then reduce the heat to medium–low, cover the pan with a lid and cook for 40–45 minutes, until the lentils have softened.

Carefully add the roasted aubergine to the lentils, then reduce the heat to low, cover the pan with a lid and cook for a final 10 minutes, until the aubergine pieces are warmed through. Serve immediately.

There is very little work to be done when making this dish, so it's the recipe to reach for when you're super-busy. You can serve it as a soup or with rice or chapatti. If you are having it as a soup, try garnishing it with a dollop of natural yogurt and some chilli flakes. And if you are having it with rice, I suggest you add some chutney to the mix.

Red Lentils with Spinach

SERVES 4

400g (14oz) red lentils
1.2 litres (2 pints) water
1 teaspoon salt
1 teaspoon ground turmeric
150g (5½oz) spinach leaves, roughly chopped
1 tablespoon ghee
1 teaspoon cumin seeds
pinch of asafoetida
2 garlic cloves, thinly sliced
1 small green chilli, finely chopped

Put the lentils into a large saucepan with the measured water, salt and turmeric and bring to the boil. Cover the pan with a lid and simmer over medium–low heat for 15–20 minutes, until the lentils are fully cooked. Mix in the spinach, then take the pan off the heat.

Heat the ghee in a small saucepan over medium–low heat. Add the cumin seeds and asafoetida and let them sizzle for a few seconds, then stir in the garlic and green chilli and cook for 1–2 minutes, until the garlic and chilli are soft and the mixture is fragrant.

Pour the spicy ghee over the cooked red lentils and serve immediately.

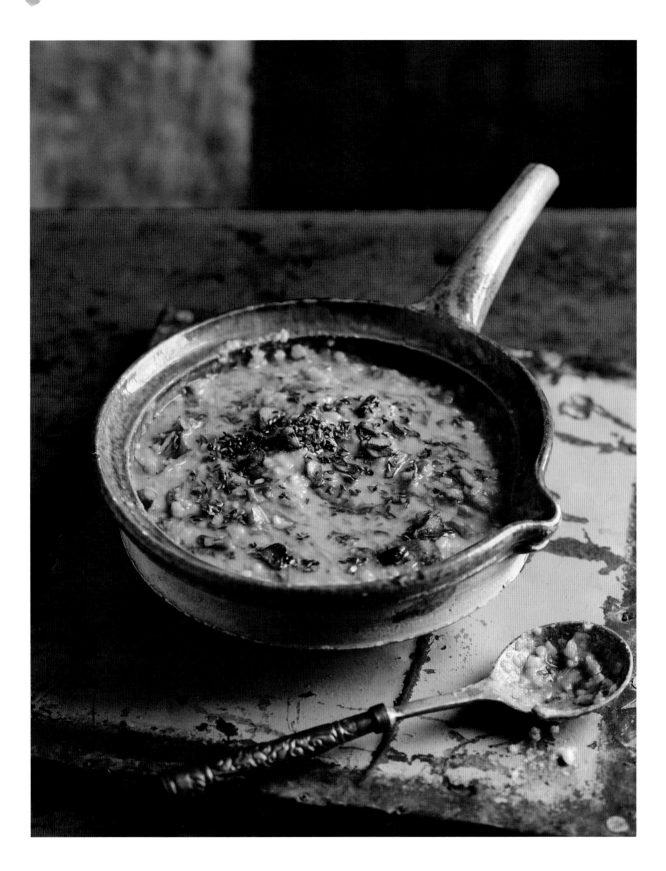

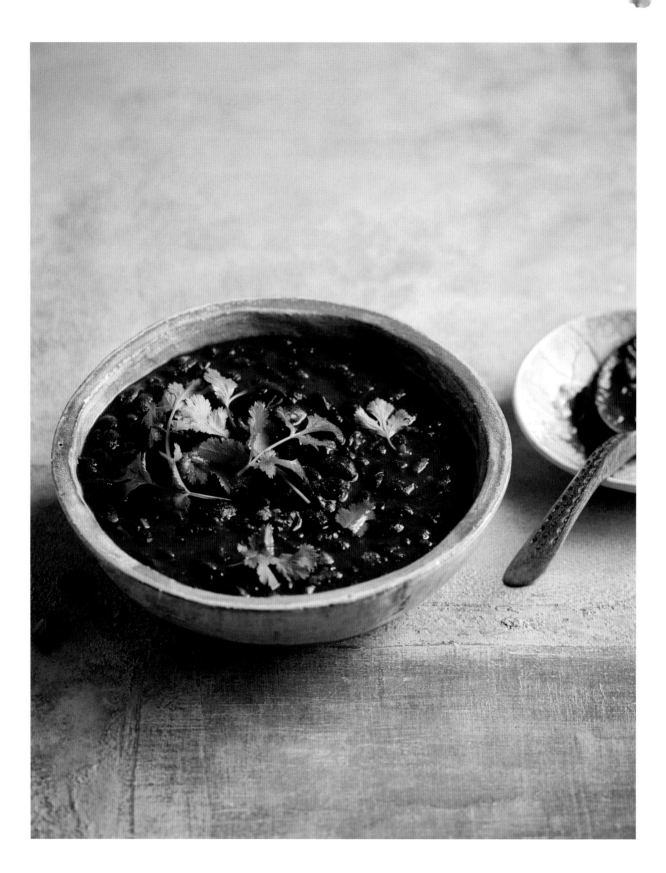

This hearty, comforting dish is my mum's recipe – one I especially enjoy making for my children and which I'd love for them to learn how to make one day, too. The onion and tomato base infuses the beans with a deeply rich flavour. Serve it with yogurt and flatbreads or fluffy rice.

Red Kidney Bean Curry

SERVES 4

400g (14oz) dried red kidney beans (or use 2 x 400g/14oz canned beans)

1.4 litres (2½ pints) water, for soaking

1½ teaspoons salt

600ml (20fl oz) boiling water

1 tablespoon sunflower oil

1 teaspoon cumin seeds

1 large onion, finely chopped

2 garlic cloves, finely chopped

1cm (½ inch) piece of fresh root ginger, peeled and finely chopped

2 tomatoes, finely chopped

1 tablespoon ground coriander

1 teaspoon chilli powder

1 teaspoon garam masala

1 teaspoon ground turmeric

30g (1oz) fresh coriander leaves, to garnish

If you're using dried beans, put them into a deep saucepan, add the measured soaking water and leave to soak overnight. Next day, add the salt and bring to the boil. Half-cover the pan with a lid and boil the beans for 1 hour. Add the measured boiling water, reduce the heat and simmer for another hour or until the beans are tender and cooked through. Set aside. (Alternatively, skip this step and use canned red kidney beans.)

Heat the oil in a large saucepan over medium–low heat. Once hot, add the cumin seeds and cook for 1–2 minutes, until they begin to sizzle. Stir in the onion and cook for 8–10 minutes, until golden brown. Now add the garlic and ginger and cook for 2 minutes, then stir in the chopped tomatoes. Cover the pan with a lid and cook over low heat for 10 minutes, until the tomato has broken down somewhat.

Add the ground coriander, chilli powder, garam masala and ground turmeric to the saucepan and mix well. Now add the kidney beans and give it all a good stir, then cover the pan with a lid and simmer over low heat for 20–30 minutes, until the sauce has thickened. Sprinkle over the fresh coriander to serve.

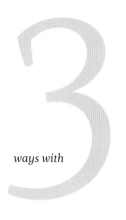

3

ways with

The epitome of comfort food for me is a big bowlful of steaming hot rice smothered in this dal, with garlic pickle on the side – it's an absolute dream. Serve the dal on its own as a big bowl of soup, or with rice or chapatti. You could add a tasty topping, if you like – my suggestions are all quick to put together. This could easily become one of those dishes you cook every week. It tastes divine any way you choose to serve it.

Tadka Dal, Three Ways

SERVES 4–6

300g (10½oz) pigeon peas (toor dal)
1½ teaspoons salt
1 teaspoon ground turmeric
1 litre (1¾ pints) water
400ml (14fl oz) boiling water

Put the pigeon peas, salt and turmeric into a deep saucepan with the measured water and bring to the boil. Reduce the heat to low, cover the pan with a lid and cook for 20 minutes, until there is very little liquid remaining in the pan.

Add the measured boiling water to the saucepan, then re-cover the pan and cook for another 20 minutes or until the lentils are soft.

Pour the dal into a serving bowl and add your chosen topping (*see* pages 94–5), mixing it in slightly. Serve immediately.

1 with tomato, red onion & coriander
2 with chilli & gram flour dumplings
3 with spicy okra

Tadka Dal, Three Ways

1

with tomato, red onion & coriander

1 tablespoon ghee
1 teaspoon cumin seeds
10 curry leaves
1 red onion, finely chopped
2 garlic cloves, thinly sliced
1 tomato, finely chopped
½ teaspoon chilli powder
30g (1oz) fresh coriander leaves

Heat the ghee in a saucepan over medium–low heat. Add the cumin seeds and curry leaves and let them sizzle for a few seconds, then stir in the chopped onion. Cook over medium heat for 5–7 minutes, until the onion is light golden. Stir in the garlic, cook for 1 minute, then mix in the tomato and cook for 5 minutes, until this softens slightly. Stir in the chilli powder and coriander leaves and take the pan off the heat.

2

with chilli &
gram flour dumplings

I quantity gram flour dumplings (see pages 68–9)
I tablespoon ghee
I teaspoon black mustard seeds
pinch of asafoetida
2 small green chillies, thinly sliced lengthways

Make the dumplings following the instructions
on page 68 for making, boiling and slicing
dumplings. Heat the ghee in a saucepan over
medium–low heat. Add the mustard seeds,
asafoetida and green chillies and cook for few
seconds, until sizzling, then add the sliced
dumplings. Cook for 2 minutes over high heat,
turning once, until light golden on both sides.

3

with spicy okra

I tablespoon ghee
I teaspoon cumin seeds
200g (7oz) okra, cut into 5mm (¼ inch) pieces
¼ teaspoon salt
¼ teaspoon chilli powder
¼ teaspoon mango powder (amchur)

Heat the ghee in a saucepan over medium–low
heat. Add the cumin seeds and let them sizzle
for a few seconds. Stir in the okra, increase the
heat to high and cook for 5 minutes, until the
pieces start to colour. Cover the pan with a lid,
reduce the heat to low and cook for 7–8 minutes,
until the okra has softened. Stir in the salt and
chilli and mango powders, mixing well.

It takes just a few basic spices to elevate a humble ingredient like barley, as shown in this tasty dish. You'll love the crunchy texture the peanuts bring. Packed with colour and flavour, this dish makes a great meal and is brilliant served with chutney, raita or salad. It's perfect for packed lunches, so you know what to do with any leftovers!

Barley with Vegetables & Peanuts

SERVES 4

200g (7oz) pearl barley

1 litre (1¾ pints) water

1 tablespoon sunflower oil

1 teaspoon cumin seeds

1 onion, finely chopped

100g (3½oz) toasted peanuts, lightly crushed using a pestle and mortar

5 spring onions, finely chopped

1 carrot, finely chopped

1 red pepper, cored, deseeded and finely chopped

1 green pepper, cored, deseeded and finely chopped

1 teaspoon salt

½ teaspoon chilli powder

½ teaspoon ground cumin

½ teaspoon garam masala

pinch of freshly ground black pepper

juice of 1 lime

Put the barley into a saucepan with the measured water and bring to the boil – this could take up to 10 minutes. Once it's boiling, reduce the heat to low, partly cover the pan with a lid and simmer for 50 minutes or until the barley is tender. Drain the barley and set aside.

Meanwhile, heat the oil in a large saucepan over medium–low heat. Add the cumin seeds and cook for 1–2 minutes, until they start to sizzle. Stir in the onion, increase the heat to medium and cook for 2 minutes, until it begins to soften.

Add the lightly crushed peanuts to the saucepan with the spring onions, carrot and peppers. Cover the pan with a lid, reduce the heat to low and cook for 10 minutes, until the vegetables are slightly cooked but retain crispness and bite.

Now add the salt, spices, pepper and cooked barley to the saucepan and mix well. Increase the heat to high and cook for 1 minute, then mix in the lime juice. Serve immediately.

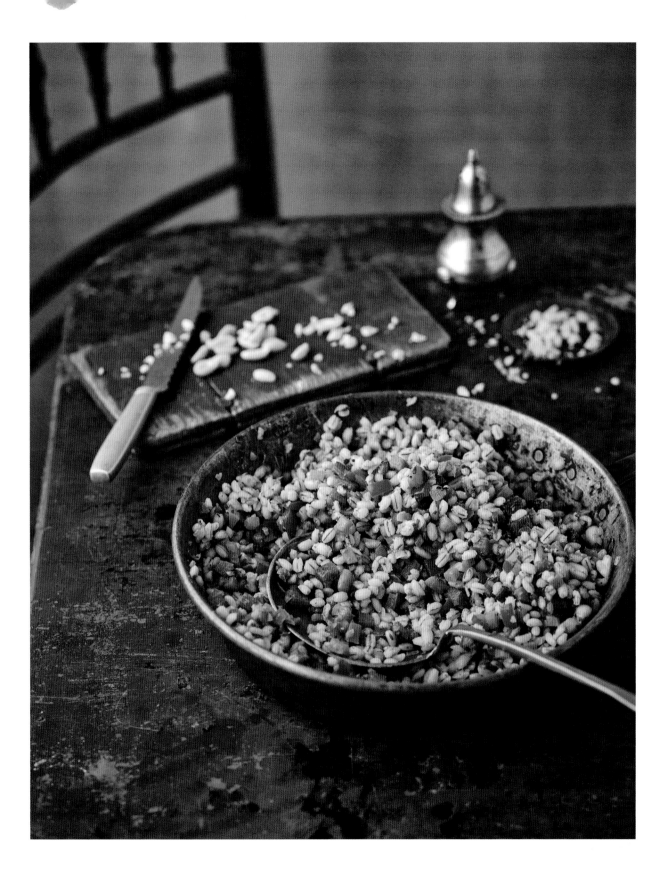

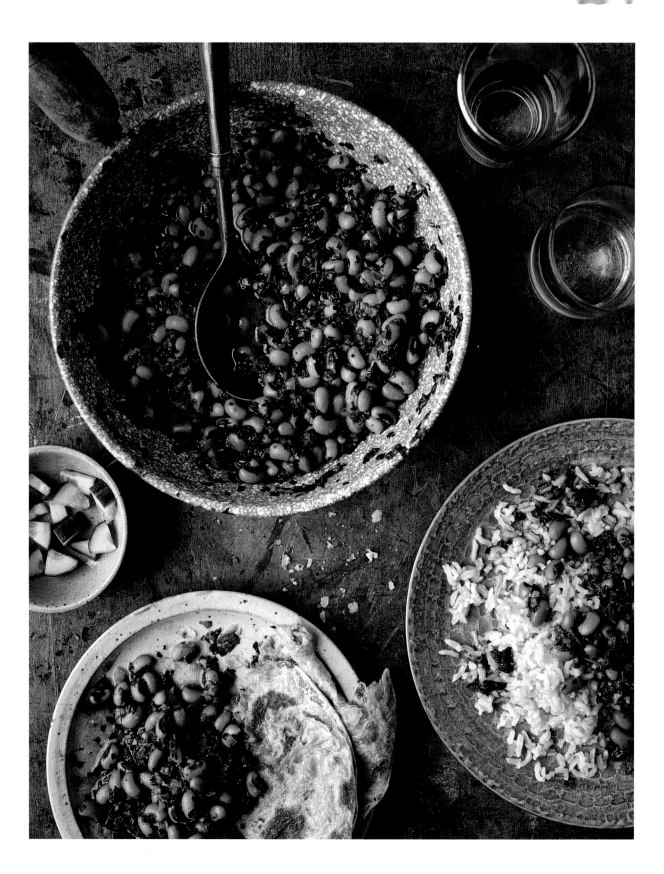

Robust shreds of cavolo nero bring texture to this wonderfully comforting dish, and their earthy flavour complements the equally earthy taste of black eyed beans well. Serve this dish alone as a soup, or with chapatti or rice.

Black Eyed Beans with Cavolo Nero

SERVES 4

250g (9oz) dried black eyed beans

850ml (1½ pints) water, for soaking

1½ teaspoons salt

1 teaspoon ground turmeric

850ml (1½ pints) boiling water

1 tablespoon ghee

1 teaspoon cumin seeds

1 large onion, roughly chopped

1 small green chilli, finely chopped

200g (7oz) cavolo nero, finely chopped

2 tomatoes, roughly chopped

1 teaspoon garam masala

½ teaspoon chilli powder

Put the beans and measured soaking water into a large saucepan and leave to soak for a couple of hours, until the beans are swollen.

Mix 1 teaspoon of the salt and the turmeric into the saucepan and bring to the boil. Cover the pan with a lid and simmer for 30 minutes, until there is very little liquid left. Add the measured boiling water and cook for another 30 minutes, until the beans are cooked. Set aside.

Meanwhile, heat the ghee in a saucepan over low heat. Add the cumin seeds and let them sizzle for a few seconds, then stir in the onion and green chilli and cook for 5 minutes, until the onion is softened. Next, mix in the cavolo nero and tomatoes, then cover the pan with a lid and cook for 15 minutes, until the leaves are soft.

Take the pan off the heat and allow the vegetable mixture to cool for 5 minutes, then tip it into the jug of a blender and blend it coarsely – you don't want the sauce to be smooth like a purée, but ensure there are no large lumps. Return the sauce to the pan. Mix in the remaining salt, the garam masala and chilli powder, then stir in the cooked beans. To finish, simmer over high heat for 2 minutes, to ensure everything is warmed through. Serve immediately.

Roasting butternut squash before adding it to this dal makes it oh-so good! It does add to the cooking time (believe me – it is well worth it) but requires very little extra prep work. The earthy taste of the red lentils complements the velvety roasted squash, and the spices, tamarind and jaggery bring in a lively blend of flavours. You can serve this soupy dal alone, or accompanied by rice or chapatti.

Butternut Squash with Red Lentils & Tamarind

SERVES 4

1 tablespoon mustard oil

1 teaspoon fenugreek seeds

1 teaspoon nigella seeds (kalonji)

2 onions, finely chopped

200g (7oz) red lentils (massur dal)

1 teaspoon salt

1 teaspoon ground coriander

½ teaspoon chilli powder

1.2 litres (2 pints) boiling water

1 tablespoon tamarind paste

1 tablespoon grated jaggery or brown sugar

2 tablespoons coconut cream

handful of fresh coriander leaves, to garnish (optional)

For the squash

1 butternut squash, peeled and cut into 2.5cm (1 inch) dice

1 teaspoon nigella seeds (kalonji)

½ teaspoon dried red chilli flakes

½ teaspoon salt

1 tablespoon sunflower oil

First, roast the squash. Preheat the oven to 180°C (350°F), Gas Mark 4. Spread out the diced squash on a baking tray and sprinkle over the nigella seeds, chilli flakes and salt. Drizzle with the oil and mix well. Roast for 40 minutes, until soft and lightly browned.

Meanwhile, start making the dal. Heat the mustard oil in a large saucepan over medium–low heat until it begins to smoke. Add the fenugreek and nigella seeds and let them sizzle for 1–2 minutes, then add the onions and cook for 10 minutes, until softened.

Tip in the lentils, salt, ground coriander and chilli powder and mix well. Pour in the measured boiling water and bring to the boil. Cover the pan with a lid and cook over medium–low heat for 15 minutes or until the lentils are cooked.

Stir the tamarind paste and jaggery into the saucepan, then carefully mix in the roasted butternut squash. Reduce the heat to low, cover the pan with a lid and simmer for 10 minutes, until the dal has thickened.

Add the coconut cream and mix well. Take the pan off the heat and sprinkle over the coriander leaves, if using them. Serve immediately.

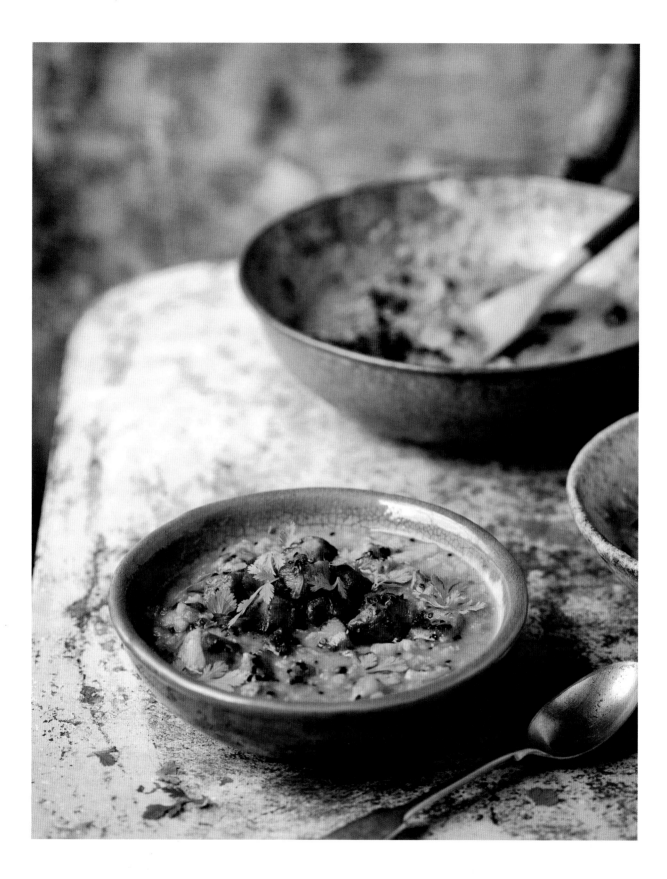

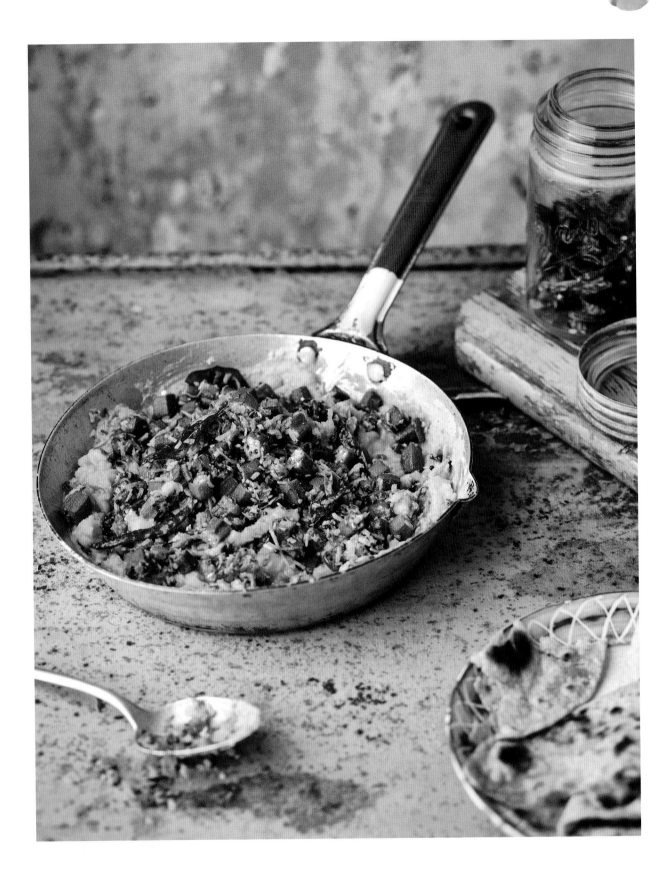

Although this is an unusual combination of flavours, chana dal, okra and fresh coconut work amazingly well together. Chana dal is heavier than other lentils, but here it tastes fresh and light, thanks to the influence of the other ingredients. You'll find this dish very easy to make. Serve it with chapatti or rice.

Chana Dal with Okra & Coconut

SERVES 4

250g (9oz) split chickpeas (chana dal)

1½ teaspoons salt

1 teaspoon ground turmeric

1 litre (1¾ pints) boiling water

1 tablespoon ghee

1 teaspoon black mustard seeds

10 curry leaves

4 dried red chillies

4 banana shallots, cut into thin circles

400g (14oz) okra, cut into 1cm (½ inch) pieces

½ teaspoon chilli powder

1 teaspoon ground cumin

1 teaspoon garam masala

100g (3½oz) fresh coconut, very finely chopped

Put the chana dal into a deep saucepan with 1 teaspoon of the salt, the turmeric and the measured boiling water. Cover the pan with a lid and cook over medium–low heat for 45–50 minutes, until the lentils are soft and all the water has been absorbed. Set aside.

Heat the ghee in a separate large saucepan over medium–low heat. Add the mustard seeds, curry leaves and dried red chillies and cook for a few seconds, until they begin to sizzle. Stir in the shallots and cook for 2 minutes, until they begin to soften.

Increase the heat under the saucepan to medium, mix in the okra and cook for about 5 minutes, until it begins to turn slimy (don't worry about the slime at this point – it will disappear during cooking).

Stir in the remaining salt, the spices and coconut, then reduce the heat to low, cover the pan with a lid and cook for 15–20 minutes, until the okra has softened and the slime has disappeared.

Add the cooked lentils to the okra, mixing well. Serve immediately.

Black chickpeas have a slightly different flavour to the regular, beige-coloured chickpeas – a little nuttier, perhaps – and their texture is more robust, so they don't become completely soft during cooking, and they don't break down and crumble apart. They are cooked with just a few basic spices in this simple dish that's full of flavour. In India, it is often eaten with deep-fried puris, but I suggest serving it with chapatti or rice, with chutney and salad.

Masala Black Chickpeas

SERVES 4

300g (10½oz) dried black chickpeas (kala chana)

2 litres (3½ pints) water, for soaking

1 teaspoon salt

1 tablespoon ghee

1 teaspoon cumin seeds

pinch of asafoetida

1cm (½ inch) piece of fresh root ginger, peeled and finely shredded

2 small green chillies, thinly sliced

2 teaspoons ground coriander

1 teaspoon garam masala

200ml (⅓ pint) water

To garnish

handful of chopped chives

1 lime, cut into 4 wedges

Put the black chickpeas into a large saucepan with the measured soaking water and leave to soak for 6–7 hours or overnight.

When ready to cook, add the salt and bring to the boil. Then reduce the heat to medium–low, part-cover the pan with a lid and cook for 40–45 minutes, until the chickpeas are tender and almost all the water has bubbled away. Set aside.

Heat the ghee in a large saucepan over medium heat. Add the cumin seeds and asafoetida and cook for 1–2 minutes, until they begin to sizzle. Reduce the heat to low, stir in the ginger and green chillies and cook for 1 minute. Now add the ground coriander and garam masala and cook for just 10 seconds, then pour in the measured water and bring to the boil.

Tip the cooked chickpeas into the saucepan and mix well. Cover the pan with a lid and cook over low heat for 10 minutes, to allow the chickpeas to take on the flavour of the masala.

Divide the chickpeas between 4 serving bowls, then top each bowlful with the chives and a lime wedge, so each person can squeeze it over their chickpeas. Serve immediately.

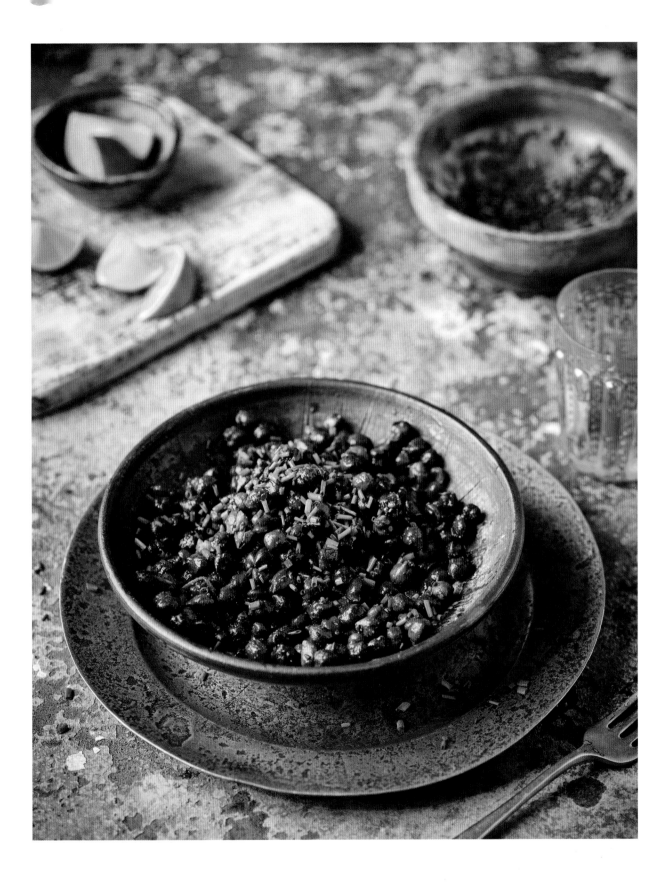

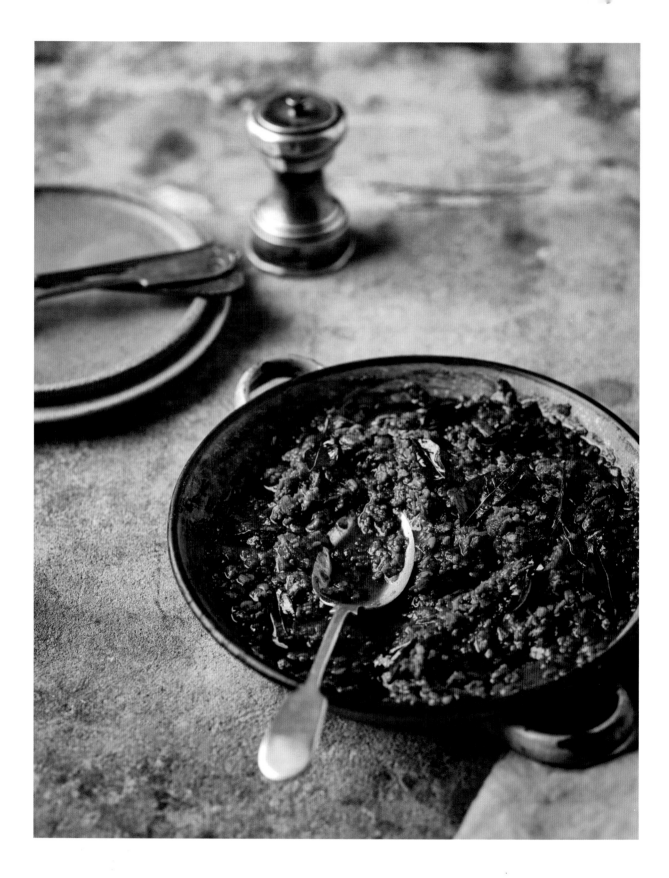

I thoroughly enjoy this dish with warm chapatti, although it's also great with rice or, alternatively, with green salad in a wrap. I love how easy it is to make. The lentils and beetroot really complement one other – all that's needed to bring them together is a little cumin and chilli.

Beetroot Sabji with Moong Dal

SERVES 4

1 tablespoon sunflower oil
pinch of asafoetida
1 teaspoon mustard seeds
10 curry leaves
1 onion, finely chopped
200g (7oz) split yellow moong lentils (moong dal)
600ml (20fl oz) boiling water
1 large beetroot, grated
1 teaspoon salt
1 teaspoon ground cumin
½ teaspoon chilli powder

Heat the oil in a saucepan over medium–low heat. When the oil is hot, and add the asafoetida and mustard seeds. After 1–2 minutes, when they start sizzling, throw in the curry leaves, then the onion, and cook for 5 minutes, until the onion has softened.

Add the moong dal and measured boiling water to the saucepan. Stir well, then cover the pan with a lid, reduce the heat to low and cook for 10 minutes, until the dal is half cooked.

Add the grated beetroot, salt, cumin and chilli powder and mix well. Cover the pan and cook for 20–25 minutes, until the dal is soft. Serve immediately.

Mung bean sprouts are easy to make at home, but if you don't have time, they are readily available in many grocery stores, which can make this dish even more quick and simple to prepare! The curry leaves and tomatoes work well with the flavour of the bean sprouts. Unaccompanied, this is a great lunch dish, or serve it alongside chicken, fish or any other vegetable dish.

Sprouted Moong Sabji

SERVES 4

200g (7oz) whole green mung beans (moong sabut)
1 tablespoon sunflower oil
pinch of asafoetida
10 curry leaves
1 teaspoon black mustard seeds
3 tomatoes, finely chopped
1 teaspoon salt
1 teaspoon caster sugar
1 teaspoon chaat masala
½ teaspoon chilli powder

Rinse the mung beans, then leave them to soak in a bowl of water 24 hours.

Next day, rinse them again thoroughly and put them into a shallow bowl (I use a cake tin). Cover the receptacle with a wet muslin cloth and leave to sprout in a dark place for 2 days, ensuring you dampen the muslin twice a day. The bean sprouts are ready when they are about 2.5cm (1 inch) long.

When ready to cook, heat the oil in a medium saucepan over medium heat. Add the asafoetida and let it sizzle briefly, then stir in the curry leaves and mustard seeds. Next, add the tomatoes and cook for 5–6 minutes, until they have softened.

Stir in the salt, sugar, chaat masala and chilli powder, then add the bean sprouts. Mix well, cover the pan with a lid and cook over medium heat for 10 minutes. Serve warm.

Hot & Spicy Coconut Prawns

Tandoori Pan-fried Sea Bream

Tamarind Fish Curry

Red Bream in Spicy Red Onion Sauce

Red Gurnard in Banana Leaf

Quick Mustard Prawn Curry

Squid & Spinach Curry

Fish

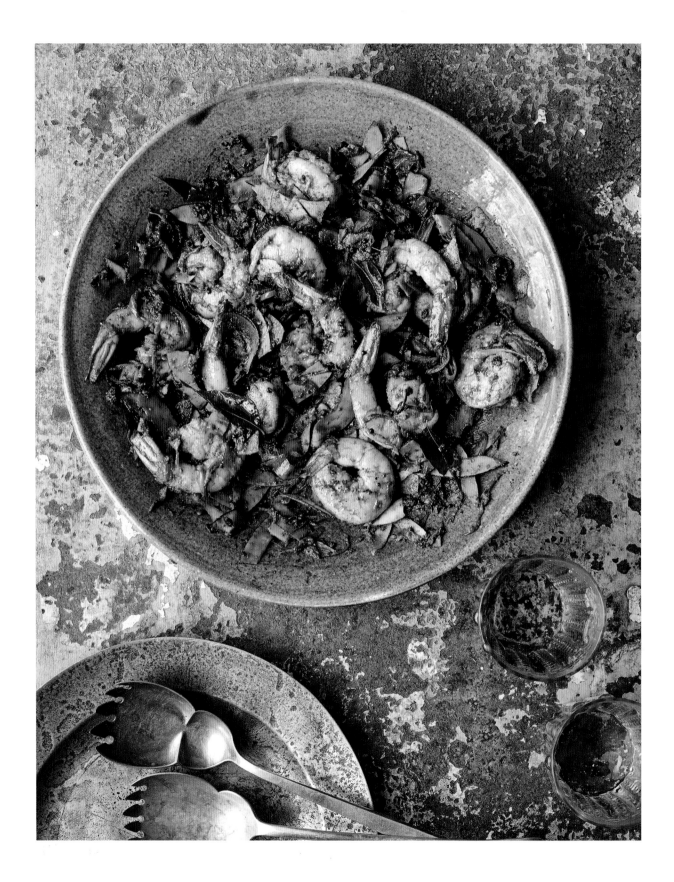

I'm warning you – this is a hot one! But, of course, you can reduce the quantity of chillies to suit your taste. The fresh prawns and big pieces of coconut are a match made in heaven. Curry leaves and fennel seeds also help to give this dish a unique flavour. Perhaps best of all, it comes together in minutes, making this a great quick-meal option. Serve it with some plain rice or pulao.

Hot & Spicy Coconut Prawns

SERVES 4

12 raw king prawns, shelled and deveined

For the dry rub

1cm (½ inch) piece of fresh root ginger, peeled and grated

2 garlic cloves, grated

¼ teaspoon salt

¼ teaspoon chilli powder

¼ teaspoon ground turmeric

¼ teaspoon crushed fennel seeds

For the masala

1 tablespoon sunflower oil

10 curry leaves

½ teaspoon black mustard seeds

½ teaspoon fennel seeds

2 small green chillies, thinly sliced

2 red onions, thinly sliced

100g (3½oz) fresh coconut, thinly sliced

150ml (¼ pint) boiling water

½ teaspoon salt

½ teaspoon ground turmeric

½ teaspoon garam masala

1 teaspoon ground coriander

1 tablespoon Kashmiri chilli powder

Put the prawns into a bowl with all the dry rub ingredients and rub them thoroughly over the prawns. Cover the bowl and leave to rest in the refrigerator for 15 minutes while you prepare the masala.

Heat the oil in a large saucepan over medium heat. Add the curry leaves and the mustard and fennel seeds and let them sizzle for a few seconds. Now stir in the green chillies and onions and cook for 2–3 minutes, until they begin to soften.

Add the coconut to the saucepan along with the measured boiling water. Stir well, then cover the pan with a lid and cook for 10 minutes, until the coconut is slightly softer.

Next, add the salt, spices and prawns to the pan and mix gently. Increase the heat to high and cook for 5–6 minutes, until the prawns have turned pink and are cooked through. Serve immediately.

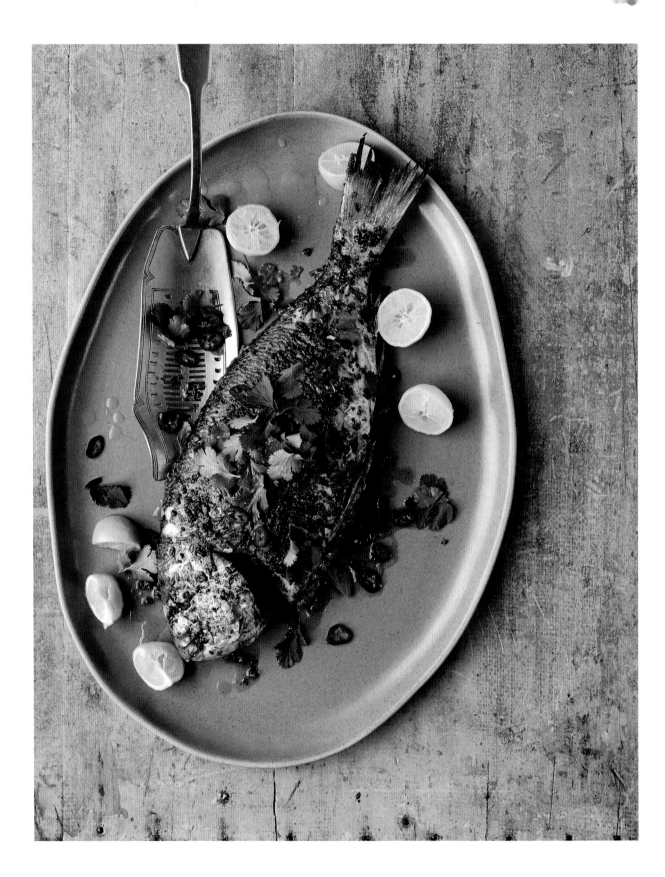

The spices, fresh herbs and yogurt in this dish make it next-level tasty. When you are short on time but still want to cook up a feast, this dish is the best thing you can try – it could not be any simpler! The bream is good-looking enough to sit in the middle of any dining table, and is great served with salads, rice, bread or even on its own.

Tandoori Pan-fried Sea Bream

SERVES 2

1 whole sea bream (500g–600g/ 1lb 2oz–1lb 5oz)

100ml (3½fl oz) natural yogurt

1cm (½ inch) piece of fresh root ginger, peeled and finely chopped

1 tablespoon tandoori masala powder

½ teaspoon chilli powder

½ teaspoon salt

40g (1½oz) fresh coriander, leaves and stems finely chopped

2 teaspoons mustard oil

For the garnish
handful of fresh coriander leaves

1 large red chilli, sliced

3 limes, halved or quartered, for squeezing over

First, score 2 cuts across each side of the fish. Place it in a large dish.

In a bowl, combine the yogurt, ginger, tandoori masala, chilli powder, salt, fresh coriander and 1 teaspoon of the mustard oil. Mix well, then spoon some of the mixture into the cavity of the fish. Spread the remainder over the outside of the fish. Leave to rest in the refrigerator for 10 minutes.

Heat the remaining mustard oil in a large frying pan over medium heat. Once it is smoking hot, carefully lay the fish in the pan and cook for 5–6 minutes on each side or until the fish is cooked through and flaky.

Serve immediately on a large plate garnished with the coriander leaves, chilli slices and lime pieces.

Cooking fish is such a joy – it's often a quick and easy job, and you can get so many different results from the same species. The layers of flavour in this curry are wonderful. The simple sauce is quick to produce, but it combines with the fish into something really special. Serve this dish with rice.

Tamarind Fish Curry

SERVES 4

700g (1lb 9oz) cod fillet, cut into 2–3cm (¾–1¼ inch) pieces

¼ teaspoon salt

¼ teaspoon ground turmeric

fresh coconut, very finely chopped, to garnish (optional)

For the sauce

1 tablespoon mustard oil

1 teaspoon mustard seeds

10 curry leaves

3 shallots, ground to a paste using a mini food processor

1 teaspoon fresh root ginger paste (made using a mini food processor or pestle and mortar)

1 teaspoon garlic paste (made using a mini food processor or pestle and mortar)

1 teaspoon ground coriander

½ teaspoon ground turmeric

½ teaspoon salt

1 tablespoon tamarind paste

400ml (14fl oz) can coconut milk

Put the cod into a large bowl and rub the pieces with the salt and turmeric. Cover the bowl with clingfilm and refrigerate until the curry is almost ready.

To make the curry sauce, heat the oil in a saucepan over medium heat. When it is smoking hot, add the mustard seeds and curry leaves. After 1–2 minutes, once they start to pop, stir in the shallot paste and cook for 3–5 minutes, until golden. Add the ginger and garlic pastes and cook for 1 minute, then stir in the coriander, turmeric and salt. Once combined, add the tamarind paste and coconut milk. Mix well, then cover the pan with a lid and cook for 8–10 minutes, until the sauce has thickened slightly.

Add the fish pieces to the sauce and cook gently for 3–4 minutes, until the fish is cooked through. Garnish with the fresh coconut, if liked, and serve immediately.

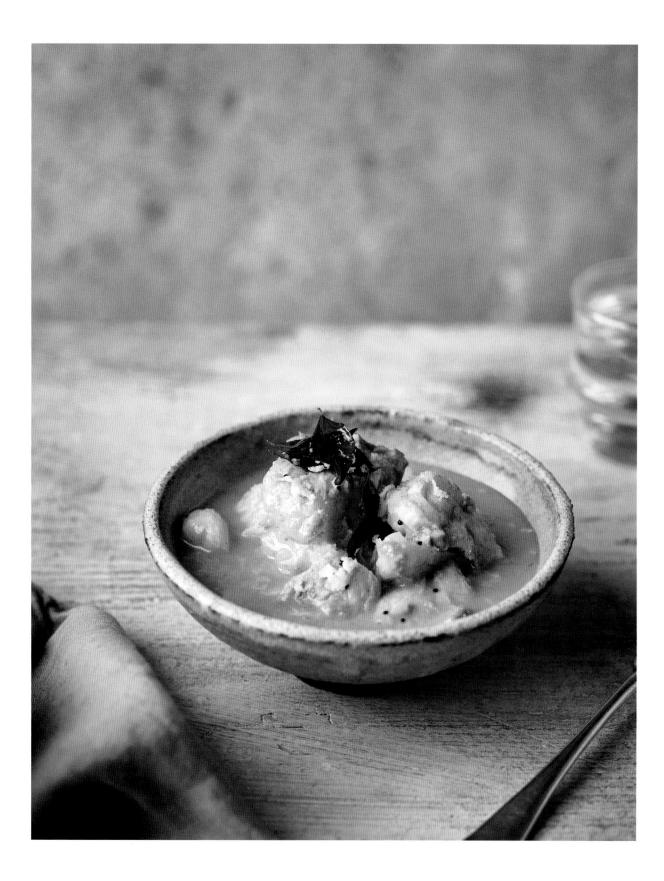

Red bream works very well in this dish, but you can use any white fish you can find – cod, sea bream or hake are great choices. Dry-toasting the spices brings out the complexities in their flavours and gives this curry its distinctive taste. Serve it with rice.

Red Bream in Spicy Red Onion Sauce

SERVES 4

1 red bream (roughly 800–900g/ 1lb 2oz–2lb), deheaded, gutted, scaled and cut into 1cm (½ inch) steaks

½ teaspoon salt

½ teaspoon chilli powder

½ teaspoon ground turmeric

2 tablespoons sunflower oil

20g (¾oz) fresh coriander, leaves and stems finely chopped

For the spicy red onion sauce

3 red onions, thinly sliced

1 red chilli, thinly sliced

4 garlic cloves, thinly sliced

2 tomatoes, thinly sliced

2 tablespoons tomato purée

1¼ teaspoons salt

¼ teaspoon sugar

1 teaspoon ground turmeric

300ml (½ pint) boiling water

For the spice blend

1 teaspoon brown mustard seeds

1 teaspoon cumin seeds

1 teaspoon fenugreek seeds

½ teaspoon black peppercorns

Lay the fish steaks on a plate. Sprinkle over the salt, chilli and turmeric and rub them into the flesh well. Refrigerate for 15 minutes.

Heat 1 tablespoon of the oil in a wide saucepan or frying pan over high heat. Add the fish and sear the steaks for about 1 minute on each side, until lightly browned. Remove the fish from the pan and set aside.

Use the same pan to make the spicy red onion sauce. Heat the remaining oil over low heat and add the onions and red chilli. Cook for 15–20 minutes, until the onions have softened and begun to turn light golden.

Meanwhile, make the spice blend. Put the spices into a small, dry frying pan and toast them over low heat for 2 minutes, stirring occasionally, until they are lightly coloured and release their aromas. Crush the toasted spices using a pestle and mortar.

Mix the garlic into the red onion sauce mixture and cook for 2 minutes, then stir in the sliced tomatoes and tomato purée. Now add the spice blend, salt, sugar and ground turmeric and mix well. Pour in the measured boiling water, then cover the pan with a lid and cook over low heat for 15–20 minutes, until the sauce is amalgamated and has thickened.

Carefully slip the fish steaks into the sauce and cook for 5–6 minutes, until the fish is cooked through and flaky. Sprinkle the fresh coriander on top and serve immediately.

Although this is a simple dish, it tastes as though someone has spent hours making it! Bold mustard, chewy coconut and creamy yogurt bring chunky white fish to life. Don't be afraid of cooking in banana leaves – it's quick and really adds to the taste. However, I do find that I have trouble finding them sometimes, and if that's the case with you, cook the fish in exactly the same way, but wrapped up in baking paper. You can also bake the fish instead of steaming it. Serve the fish in the parcels with rice alongside.

Red Gurnard in Banana Leaf

SERVES 2

1 tablespoon black mustard seeds

1 tablespoon white poppy seeds

4 tablespoons water, for soaking

1 small green chilli, roughly chopped

50g (1¾oz) fresh coconut, roughly chopped

½ teaspoon salt

½ teaspoon ground turmeric

6 tablespoons natural yogurt

1 teaspoon mustard oil

1 large banana leaf

1 red gurnard, roughly 500g (1lb 2oz), deheaded, gutted, scaled and cut into 2.5cm (1 inch) steaks

lime wedges, to garnish

Soak the mustard and poppy seeds in the measured soaking water for 1 hour before cooking.

Tip the seeds and soaking water into a food processor. Add the green chilli, fresh coconut, salt and turmeric and blitz the mixture to a smooth paste. Transfer the mixture to a bowl and stir in the yogurt and oil.

Tear the banana leaf into pieces that are large enough to wrap up each fish steak – you should have enough ingredients for at least 2 parcels per person. Place 1 fish steak on the centre of 1 piece of banana leaf, cover it with a spoonful of the coconut spice paste, then turn it over and cover the other side with more paste. Wrap up the fish in the banana leaf and secure the parcel with kitchen string. Repeat with the remaining fish steaks and spice paste.

Sit the fish parcels in a steamer basket over a pan of boiling water and cook for 6–7 minutes or until the fish is cooked through. (If using baking paper to wrap the fish, steam for around 10–12 minutes. If baking the parcels, preheat the oven to 190°C (375°F), Gas Mark 5 and bake for 10–12 minutes.) Serve immediately with lime wedges to garnish.

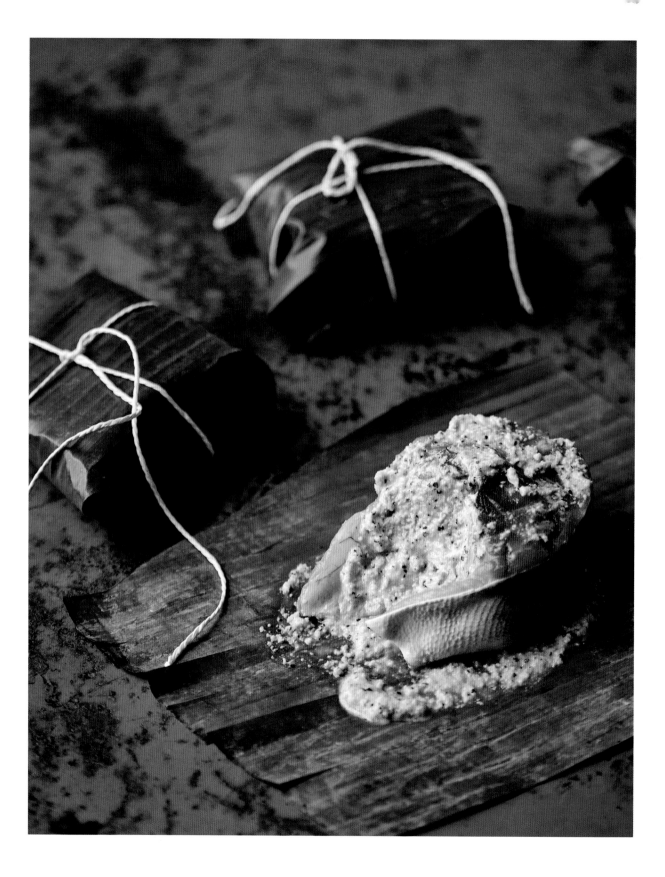

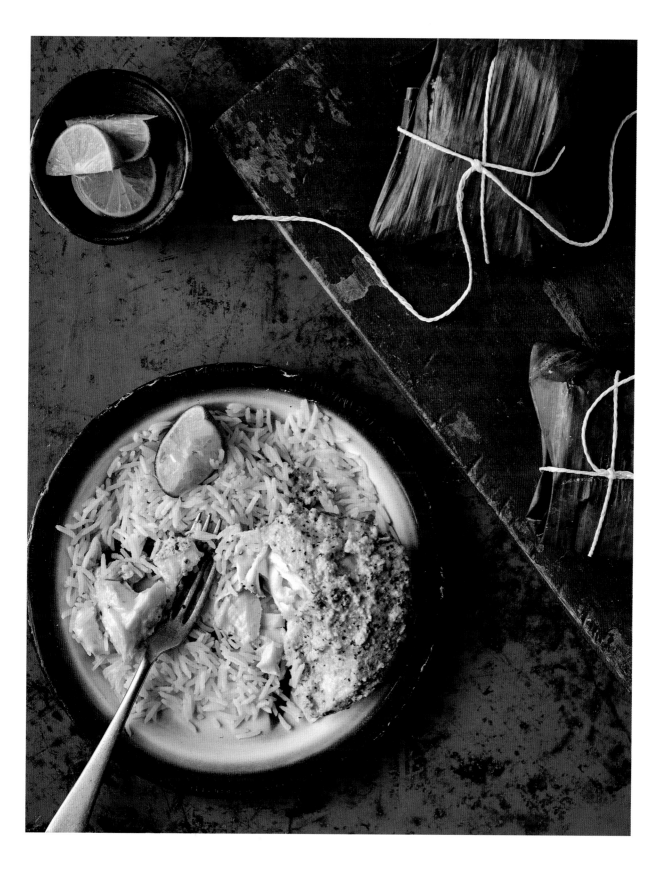

This is a handy recipe to have up your sleeve for midweek meals. It is easy and relatively quick to prepare, and the prawns can be replaced with any white fish that's available – the spice blend works well with the flavours of seafood. The key to success is to simmer the sauce slowly, which creates depth of flavour, so ensure you keep it bubbling gently for the full 15 minutes before you blend it. Serve this curry with chapatti or rice.

Quick Mustard Prawn Curry

SERVES 4

1 tablespoon mustard oil

1 teaspoon brown mustard seeds

1 onion, thinly sliced

3 garlic cloves, finely chopped

5mm (¼ inch) piece of fresh root ginger, peeled and finely chopped

400g (14oz) can chopped tomatoes

½ teaspoon salt

1 teaspoon ground coriander

½ teaspoon chilli powder

½ teaspoon ground turmeric

½ teaspoon garam masala

12 raw king prawns, shelled and deveined

1 tablespoon double cream

Heat the oil in a medium saucepan over medium–low heat. When the oil is smoking hot, add the mustard seeds and cook for 1–2 minutes, until they begin to sizzle. Stir in the onion and cook for 10 minutes, until golden.

Mix the garlic and ginger into the saucepan and cook for 2 minutes, until they begin to take on a little colour. Pour in the canned tomatoes, mix well, then cover the pan with a lid, reduce the heat to low and simmer for a good 15 minutes, until the oil has begun to separate from the sauce in little pools around the edge of the pan.

Take the pan off the heat and use a hand-held blender to whizz the sauce until smooth. (Alternatively, purée it using a blender, then pour it back into the saucepan.) Return the pan to the hob over low heat, cover with a lid and cook for 10 minutes, until you have a richly flavoured and thick sauce.

Stir the salt and the remaining spices into the saucepan, then throw in the prawns and mix carefully. Cook for 4–5 minutes, until the prawns have turned pink.

Stir in the cream and cook for 1 minute, then serve immediately.

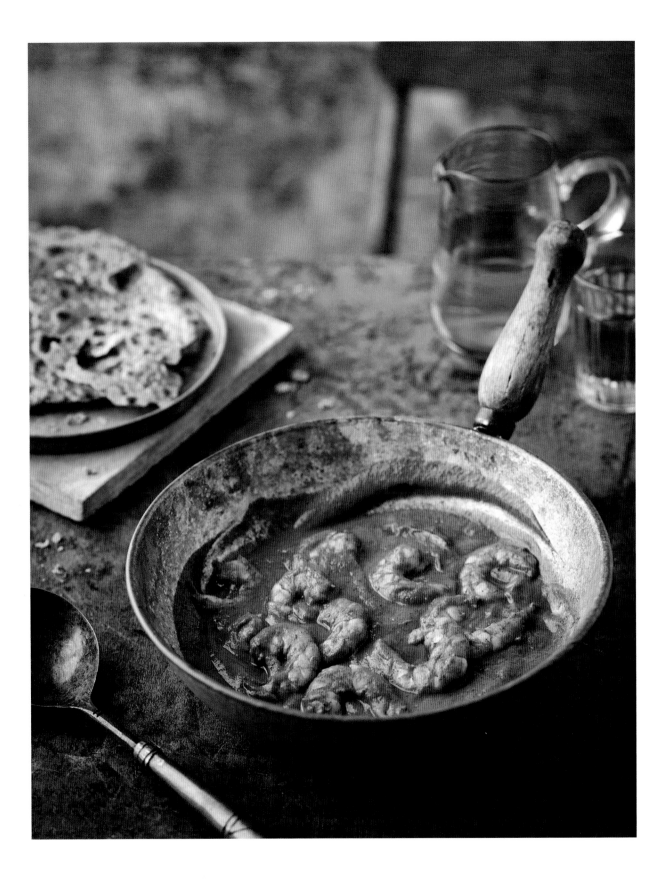

You may not have considered squid for a simple supper, but this lovely dish is quick and easy to make. The spicy masala coats the squid well, while the spinach and fresh coriander add colour and a silky texture. It only takes rice, plain chapatti or even a hunk of bread to turn this into a complete meal.

Squid & Spinach Curry

SERVES 4

1 tablespoon sunflower oil

1 teaspoon fennel seeds

1 teaspoon black mustard seeds

2 banana shallots, finely chopped

2 garlic cloves, finely chopped

1cm (½ inch) piece of fresh root ginger, peeled and finely chopped

1 small green chilli, finely chopped

2 tomatoes, finely chopped

½ teaspoon salt

½ teaspoon garam masala

½ teaspoon ground turmeric

½ teaspoon chilli powder

1 teaspoon ground coriander

400g (14oz) squid, cut into thin rings

100g (3½oz) spinach leaves, roughly chopped

40g (1½oz) fresh coriander, leaves and stems roughly chopped

Heat the oil in a large saucepan over low heat. Add the fennel and mustard seeds and cook for 1 minute or so, until they begin to sizzle. Stir in the shallots and cook for 10 minutes, until golden.

Add the garlic, ginger and green chilli and cook for another minute, then stir in the tomatoes. Cover the saucepan with a lid and cook over low heat for 10 minutes, until the tomato has softened and the ingredients are well combined.

Add the salt and all the spices to the saucepan, mix well and cook for 1 minute, then stir in the squid rings and spinach. Cover the pan with a lid once again and cook over low heat for 5–6 minutes, until the squid is just done. Stir in the coriander and serve immediately.

Chicken, Sweetcorn & Egg Soup

Peppercorn & Red Chilli Chicken Curry

Spicy Masala Roast Chicken

Chicken & Potato in Pickling Spices

Whole Tandoori-style Chicken

Coconut Chicken Curry

Spicy Chicken & Chickpea Curry Bake

Chicken Seekh Kebabs

Onion & Whole Spice Chicken Curry

Chicken with Kale & Yogurt

Chicken, Lentil & Fresh Turmeric Soup

Chicken

Uncomplicated flavours and simple ingredients make this soup seriously comforting. The freshly cooked stock, made with chicken thighs and flavoured with spring onions and soy sauce, is delicious, and the chicken and egg give the soup body and substance.

Chicken, Sweetcorn & Egg Soup

SERVES 6

4 skinless chicken thighs on the bone

2 litres (3½ pints) water

1 tablespoon sunflower oil

10 spring onions, finely chopped

200g (7oz) frozen sweetcorn

4 large eggs, beaten

1 teaspoon salt

½ teaspoon ground turmeric

½ teaspoon freshly ground black pepper

1 tablespoon soy sauce

Put the chicken into a deep saucepan with the measured water and bring to the boil. Reduce the heat to medium–low, cover the pan with a lid and cook gently for 45 minutes, until the stock is well flavoured. Strain the stock into a jug and set aside. Once the chicken pieces are cool enough to handle, shred the meat into small pieces and set aside.

Heat the oil in another deep saucepan over medium heat. Add the spring onions and cook for 2 minutes, until they begin to soften. Stir in the sweetcorn and cook for a further 2 minutes, until it starts to soften. Now pour in the chicken stock, mix in the shredded chicken, increase the heat to high and cook for 1 minute.

Using a fork, stir the stock continuously as you slowly drizzle the beaten eggs into it. Keep stirring until all the eggs have been added – this will form threads of egg in the soup.

Finally, add the salt, turmeric, pepper and soy sauce and mix well. Serve immediately.

A feisty blend of freshly toasted and ground spices gives this chicken curry a beautiful kick, and if you have any leftovers, you'll find the flavours are even better the following day. Serve with rice or chapatti and some Carrot & Onion Pickle (*see* page 183).

Peppercorn & Red Chilli Chicken Curry

SERVES 4

2 tablespoons sunflower oil

10 curry leaves

2 onions, chopped

3 garlic cloves

1cm (½ inch) piece of fresh root ginger, peeled and finely chopped

2 tablespoons tomato purée

300ml (½ pint) boiling water

8 skinless chicken thighs and drumsticks on the bone

1½ teaspoons salt

For the spice blend

2 teaspoons black peppercorns

2 teaspoons fennel seeds

1 teaspoon cumin seeds

4 dried red chillies

4 green cardamom pods

4 cloves

Put the spice blend ingredients into a dry frying pan and toast them over low heat for 2–3 minutes, until they take on a little colour and their aromas are released. Now grind the toasted mixture to a powder using a pestle and mortar or a spice blender. Set aside.

Heat the oil in a large saucepan over medium–low heat. Add the curry leaves and cook for 1–2 minutes, until they begin to sizzle. Add the onions, increase the heat to medium and cook for 12–15 minutes or until golden.

Meanwhile, using a pestle and mortar, crush the garlic and ginger together to make a paste. Once the onion in the saucepan is golden, stir the garlic and ginger paste into the pan and cook for 1 minute, then mix in the tomato purée and 100ml (3½fl oz) of the measured boiling water.

Stir the spice blend into the saucepan and cook for 1 minute, then mix in the chicken pieces, salt and remaining measured boiling water. Cover the pan with a lid, reduce the heat to low and simmer gently for 40–45 minutes, until the chicken is cooked through.

Turn off the heat and leave the curry to rest for 10 minutes before serving.

This fantastic dish requires very little prep time, then you simply put it into the oven and forget all about it until it is ready to serve. Red chillies give the onion and tomato mixture a lovely kick, and this spicy masala keeps the meat nice and moist in the oven. Serve the chicken with some rice when you need substantial fare, or with some salad if want a lighter meal.

Spicy Masala Roast Chicken

SERVES 4

4 skinless chicken legs on the bone

For the masala

1 onion, roughly chopped
1 tomato, roughly chopped
1 tablespoon tomato purée
1 tablespoon mustard oil
2 garlic cloves
½ teaspoon salt
½ teaspoon chilli powder
2 dried red chillies
½ teaspoon garam masala
½ teaspoon ground turmeric

Use a mini food processor to combine the masala ingredients – blitz until you have a smooth paste.

Place the chicken pieces in a roasting tin and cover them with the masala paste. Now rub it into the flesh well. Leave to marinate for 15 minutes. Meanwhile, Preheat the oven to 180°C (350°F), Gas Mark 4.

Once the marinating time has elapsed, roast the chicken for 50–55 minutes, until it is cooked through. Serve immediately.

It is the combination of mustard oil and spices that are normally used for pickling that makes this chicken curry taste very different from the others in this book. It has a deep, spicy taste with an interesting character that is well worth trying. I like to keep the skin on the potatoes to give the dish a little more body – and fibre, too. Serve this curry with chapatti or rice.

Chicken & Potato in Pickling Spices

SERVES 4

2 tablespoons mustard oil

pinch of asafoetida

1 teaspoon black mustard seeds

1 teaspoon fenugreek seeds

1 teaspoon cumin seeds

2 teaspoons fennel seeds

2 teaspoons nigella seeds (kalonji)

4 dried red chillies

2 red onions, finely chopped

4 garlic cloves, finely chopped

1cm (½ inch) piece of fresh root ginger, peeled and finely chopped

2 tablespoons tomato purée

1½ teaspoons salt

1 teaspoon ground turmeric

1 teaspoon chilli powder

8 skinless chicken pieces on the bone (I use 4 thighs and 4 drumsticks)

100ml (3½fl oz) natural yogurt

2 teaspoons Kashmiri chilli powder

2 medium potatoes (skins on), sliced into 1cm (½ inch) discs

Heat the oil in a large saucepan over medium–low heat until it is smoking hot. Add the asafoetida and let it sizzle for a few seconds, then stir in all the seeds plus the dried red chillies. Increase the heat to medium and allow them to sizzle for about 1 minute more, ensuring they do not burn. Once the seeds start to change colour, add the onions and cook for 10–12 minutes, until the onions are golden brown.

Stir the garlic and ginger into the saucepan and cook for another minute, then mix in the tomato purée, followed by the salt, turmeric and chilli powder. Mix well.

Add the chicken pieces to the saucepan, increase the heat to high and stir for 2 minutes. Now cover the pan with a lid, reduce the heat to low and cook for 30 minutes, until the chicken is half cooked.

Mix the yogurt and Kashmiri chilli powder together in a bowl. Stir this mixture into the saucepan along with the potato discs. Combine well, then cover the pan with a lid and simmer gently over low heat for 20–25 minutes, until the chicken and potatoes are cooked through. Serve immediately.

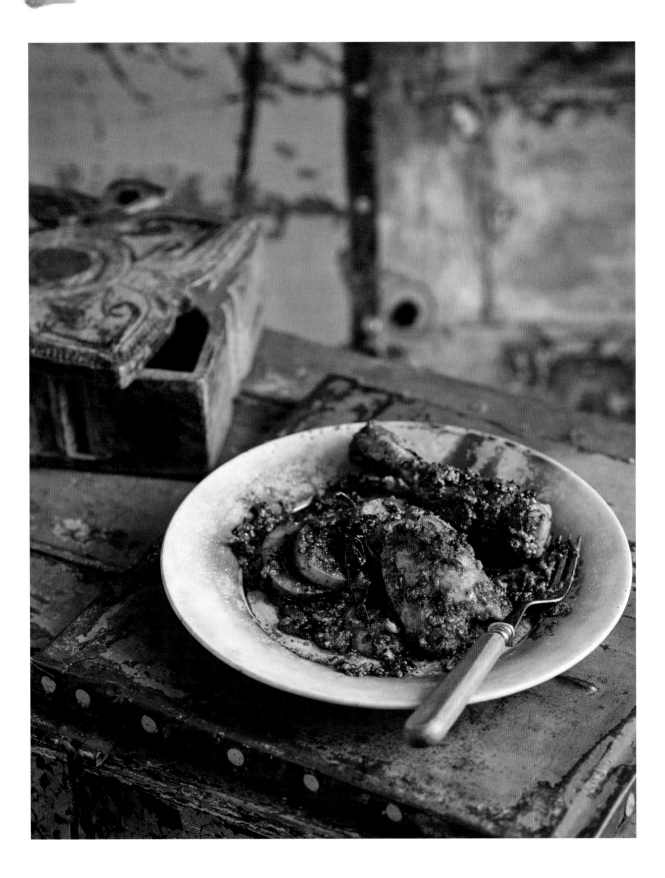

I have tried and tested this famous dish with various spices over the years and have found this version works perfectly every time. It's cooked in a regular oven rather than a tandoor, but it also works well on the barbecue, which lends the dish an extra smoky flavour. If you prefer, use small cuts of chicken, such as drumsticks or thighs, instead of the whole bird. This dish is great served with salad or pulao.

Whole Tandoori-style Chicken

SERVES 3–4

1 whole chicken, around 1.5kg (3lb 5oz)

For the first marinade

1 teaspoon salt

1 teaspoon Kashmiri chilli powder

10 garlic cloves, finely chopped

3–4cm (1¼–1½ inch) piece of fresh root ginger, peeled and finely chopped

4 tablespoons lemon juice

For the second marinade

200ml (⅓ pint) natural yogurt

1 tablespoon ground coriander

1 tablespoon garam masala

2 tablespoons tandoori masala powder

1 teaspoon mango powder (amchur)

1 teaspoon salt

1 tablespoon mustard oil

40g (1½oz) fresh coriander, leaves and stems finely chopped

Combine the ingredients for the first marinade in a small bowl and mix well. Rub this all over the chicken, then cover and leave to rest in the refrigerator for 1 hour.

Put all the ingredients for the second marinade, except the fresh coriander, into another bowl and mix well. Once combined, stir in the fresh coriander. Rub this mixture under the skin of the chicken, then rub the remainder inside the cavity. Leave to marinate in the refrigerator for 1 hour.

Preheat the oven to 180°C (350°F), Gas Mark 4. Put the chicken into a roasting tin and roast for 1 hour 20 minutes, which will give you a perfect tandoori chicken. To check it is done, pierce the thigh with a skewer – the juices should run clear. If not, continue roasting until they do.

Transfer the chicken to a serving plate and let it rest for 15 minutes before serving.

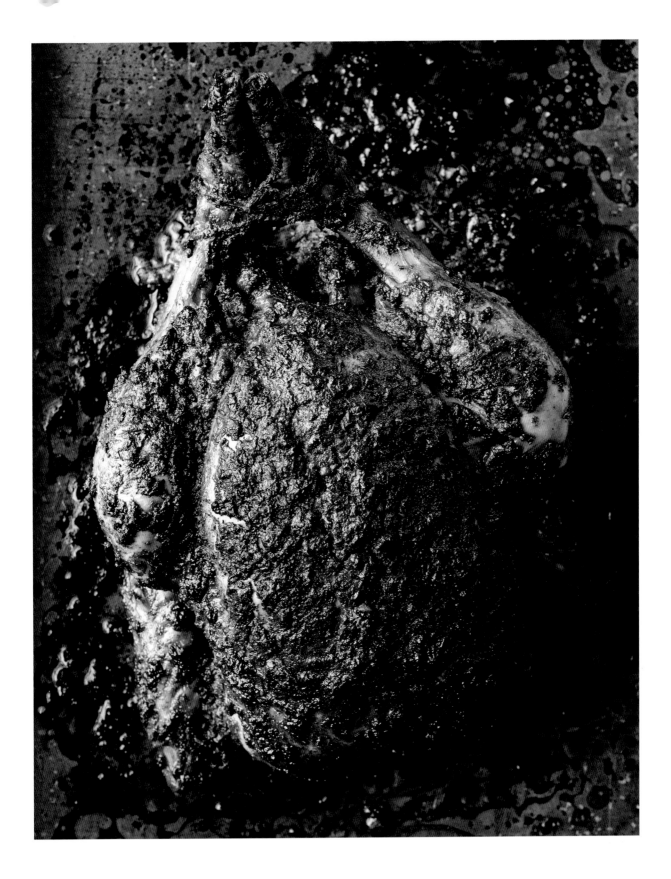

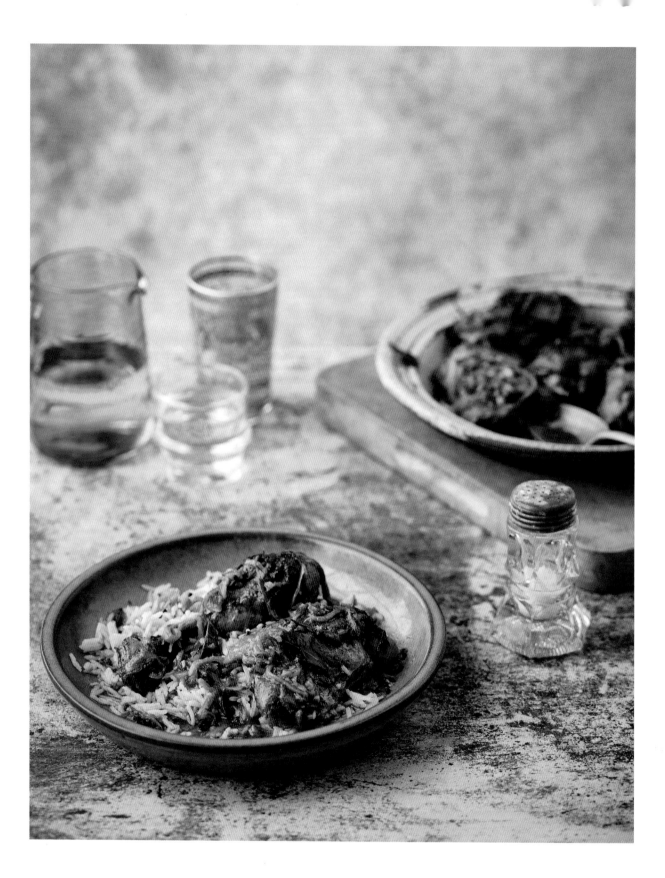

So different to the heavily spiced chicken curries you may have tried, this dish has a delicate and refreshing flavour that's best enjoyed with rice rather than bread. The light spicing works beautifully with the coconut milk, and using chicken on the bone adds extra flavour. Don't save this luxurious-tasting curry for the weekend – being quick to make, it's a great choice for midweek meals.

Coconut Chicken Curry

SERVES 4

1½ tablespoons sunflower oil

1 teaspoon mustard seeds

10 curry leaves

2 onions, thinly sliced

2 green chillies, thinly sliced

4 garlic cloves, finely chopped

1cm (½ inch) piece of fresh root ginger, peeled and finely chopped

1 teaspoon salt

1 teaspoon ground turmeric

1 teaspoon ground coriander

½ teaspoon ground cinnamon

8 skinless chicken pieces on the bone (I use 4 thighs and 4 drumsticks)

400ml (14fl oz) can coconut milk

Heat the oil in a saucepan over medium–low heat. Stir in the mustard seeds and cook for 1–2 minutes, until they start to sizzle. Now mix in the curry leaves and, after 1 minute, add the onions and green chillies. Reduce the heat to low and cook for 5–6 minutes, until the onions have softened. Stir in the garlic and ginger and cook for another 2 minutes.

Add the salt and spices to the saucepan and mix well. Cook for 1 minute, then stir in the chicken, increase the heat to high and cook for 5 minutes, until the chicken is sealed.

Stir in the coconut milk, then cover the pan with a lid, reduce the heat to low and cook for 35–40 minutes, until the chicken is cooked through. Serve immediately.

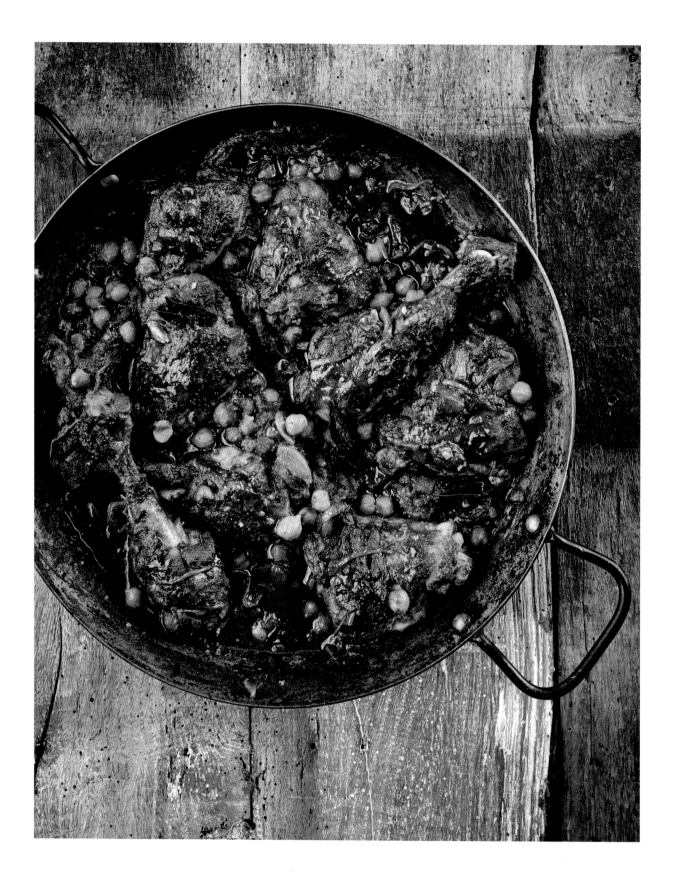

This curry features two of my favourite ingredients – chicken and chickpeas. I make it in an unusual way – the ingredients are combined in a saucepan first, then transferred to the oven. It's a good method as, once the dish is in the oven, you can forget all about it until the timer bleeps. The spicing works well with the chicken, while the chickpeas give the dish plenty of substance. Serve it with rice or naan bread and yogurt.

Spicy Chicken & Chickpea Curry Bake

SERVES 4

8 skinless chicken pieces on the bone (I use 4 thighs and 4 drumsticks)
2 tablespoons sunflower oil
I cinnamon stick
2 bay leaves
4 green cardamom pods
I teaspoon cumin seeds
10 curry leaves
2 small green chillies, finely chopped
2 onions, thinly sliced
4 garlic cloves, finely chopped
I teaspoon salt
I teaspoon ground cumin
2 teaspoons garam masala
400g (14oz) can chopped tomatoes
400g (14oz) can chickpeas

For the marinade
I teaspoon salt
I teaspoon ground turmeric
I teaspoon chilli powder
I teaspoon ground cumin
juice of I lime

Put the chicken pieces into a bowl and sprinkle over the marinade ingredients. Now rub the chicken pieces so they are well covered with the marinade. Leave to rest in the refrigerator for 15 minutes while you prepare the onions.

Preheat the oven to 180°C (350°F), Gas Mark 4.

Meanwhile, heat the oil in an ovenproof saucepan over medium–low heat. Add the cinnamon stick, bay leaves, cardamom pods and cumin seeds and let them sizzle for a few seconds. Stir in the curry leaves and green chillies and cook for few seconds more, then add the onions, increase the heat to medium and cook for 10–15 minutes, until the onions are golden brown.

Stir the garlic into the saucepan and cook for 2 minutes, then push the onions to the side of the pan. Increase the heat to high, add the marinated chicken and cook for 3–4 minutes or until it takes on some colour.

Stir in the salt, ground cumin and garam masala. Next, tip in the chopped tomatoes and chickpeas, plus their canning liquid, and mix well.

Cover the pan with a lid or kitchen foil, transfer it to the oven and bake for 35 minutes. Remove the lid or foil and bake, uncovered, for a further 15 minutes, until the chicken is cooked through. Remove the pan from the oven, cover again and leave to rest for 10 minutes. Serve warm.

These beautifully spiced and herby kebabs are great cooked over a barbecue, but can also be done in an oven or on a griddle pan, which is how I usually cook them. And you can shape the mixture into burgers to serve in a bun, if you prefer. Whatever shape or method you choose, the result will be the same – tender and delectable. Serve them on their own, or in a chapatti with chutney and salad.

Chicken Seekh Kebabs

SERVES 8

500g (1lb 2oz) skinless chicken breast fillets

4 garlic cloves

1cm (½ inch) piece of fresh root ginger, peeled

2 small green chillies

30g (1oz) fresh coriander

1 red onion, roughly chopped

¾ teaspoon salt

1 teaspoon Kashmiri chilli powder

½ teaspoon garam masala

½ teaspoon chaat masala

¼ teaspoon freshly ground black pepper

30g (1oz) Cheddar cheese, finely grated

2 tablespoons sunflower oil

To serve (optional)

red onion slices

2 tablespoons chopped coriander

chilli flakes

lime wedges

natural yogurt sprinkled with toasted cumin seeds

If using bamboo skewers, soak 8 skewers in water for 30 minutes prior to cooking.

Using a food processor, break down the chicken breasts to a smooth paste, then tip the paste into a bowl.

Now put the garlic, ginger, chillies, fresh coriander and onion into the bowl of the food processor and pulse to roughly chop and combine them. Add this mixture, along with the salt, dried spices, pepper and grated cheese, to the bowl with the minced chicken and mix thoroughly.

Divide the mixture into 8 equal portions. Press 1 portion around a skewer, then roll it between your hands to give it a somewhat cylindrical shape and extend it along the skewer. Keep a bowl of water nearby to dip your hands into between shaping each skewer, as this makes it easier to handle the somewhat sticky mixture. Place the prepared skewer on a tray or chopping board and repeat the process with the remaining portions of the chicken mixture and skewers. If necessary, you can leave the kebabs to rest in the refrigerator for up to 24 hours until you are ready to cook.

Heat the oil in a griddle pan. Cook the kebabs over medium–low heat for 8–10 minutes, turning halfway, until cooked through. Serve immediately with the red onion slices, chopped coriander, chilli flakes, lime wedges to squeeze over and cumin yogurt, if liked.

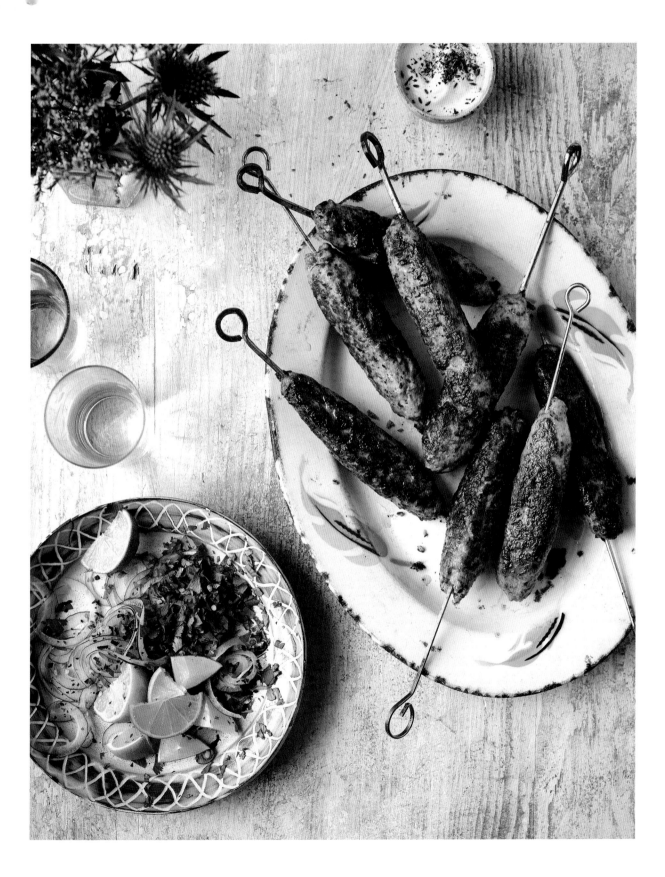

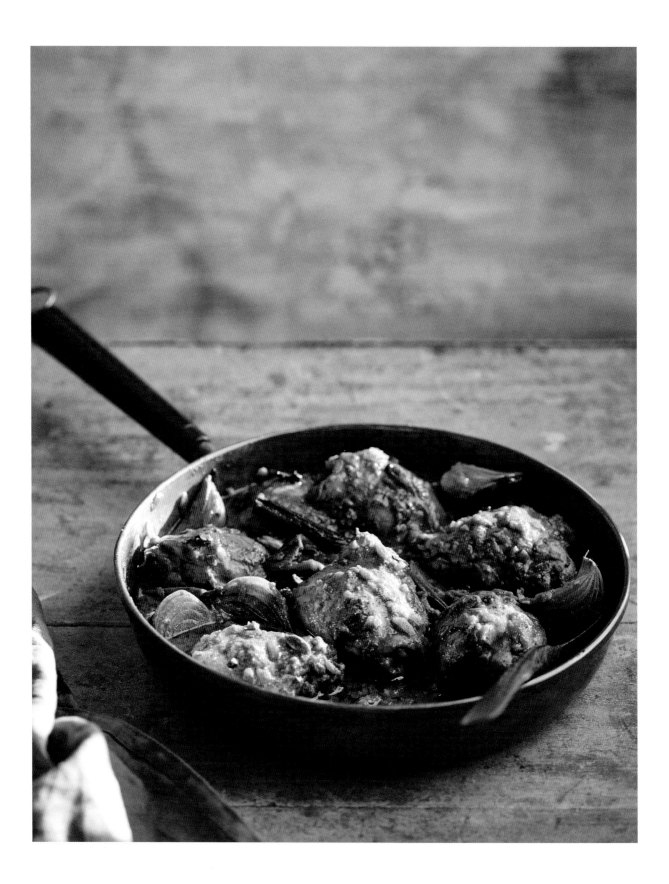

This one is my go-to recipe for making the best chicken curry in the shortest amount of time, with the least amount of effort! It will soon be your favourite, too – the spices work their magic on the chicken, and the generous use of onions gives the dish a delicious flavour. Despite the fact that it's on my list of all-time top comfort foods, this meal is very healthy. Serve it with rice or chapatti.

Onion & Whole Spice Chicken Curry

SERVES 4

1 tablespoon sunflower oil

2 bay leaves

1 cinnamon stick

8 black peppercorns

8 cloves

4 green cardamom pods

6 onions, 3 finely chopped, 3 quartered

2 small green chillies, finely chopped

2 garlic cloves, finely chopped

1cm (½ inch) piece of fresh root ginger, peeled and finely chopped

2 tablespoons tomato purée

1 tablespoon ground coriander

1 teaspoon garam masala

1 teaspoon ground turmeric

1 teaspoon salt

100ml (3½fl oz) natural yogurt

100ml (3½fl oz) boiling water

8 skinless chicken thighs on the bone

Heat the oil in a saucepan over medium–low heat. Once hot, add the bay leaves, cinnamon, peppercorns, cloves and cardamom and let them sizzle for a few seconds. Stir in the finely chopped onions and chillies and cook until the onions are golden brown – this might take 20–25 minutes.

Add the garlic and ginger to the saucepan and mix well. Continue to cook for 2 minutes, then stir in the tomato purée and cook for 2 minutes more. Now mix in the coriander, garam masala, turmeric and salt and cook for another minute.

Stir the yogurt into the saucepan along with the measured boiling water, then add the chicken and the quartered onions. Cover the pan with a lid and simmer gently for 40–45 minutes or until the chicken is cooked through. Serve immediately.

Kale and chicken isn't a typically Indian combination, but they come together well with the addition of a few storecupboard spices, and the yogurt, stirred in at the end of cooking, really makes the dish sing. If you can't get hold of kale, use spinach instead. Serve this curry with rice or chapatti.

Chicken with Kale & Yogurt

SERVES 4

1 tablespoon sunflower oil

1 teaspoon cumin seeds

2 red onions, roughly chopped

2 pieces of fresh turmeric, peeled and thinly sliced

500g (1lb 2oz) skinless chicken breast fillets, cut into 2.5cm (1 inch) dice

½ teaspoon salt

½ teaspoon chilli powder

1 tablespoon medium curry powder

100g (3½oz) curly kale

50ml (2fl oz) natural yogurt

Heat the oil in a large saucepan over medium–low heat. Add the cumin seeds and, after a minute or so, when they begin to pop, stir in the onions. Cook for 7–8 minutes, until the onions are light golden.

Add the fresh turmeric and chicken to the saucepan and mix well. Increase the heat to high and cook for 1 minute, then stir in the salt, spices and kale. Cover the pan with a lid, reduce the heat to low and cook for 15 minutes, until the chicken is done.

Stir in the yogurt to finish and serve immediately.

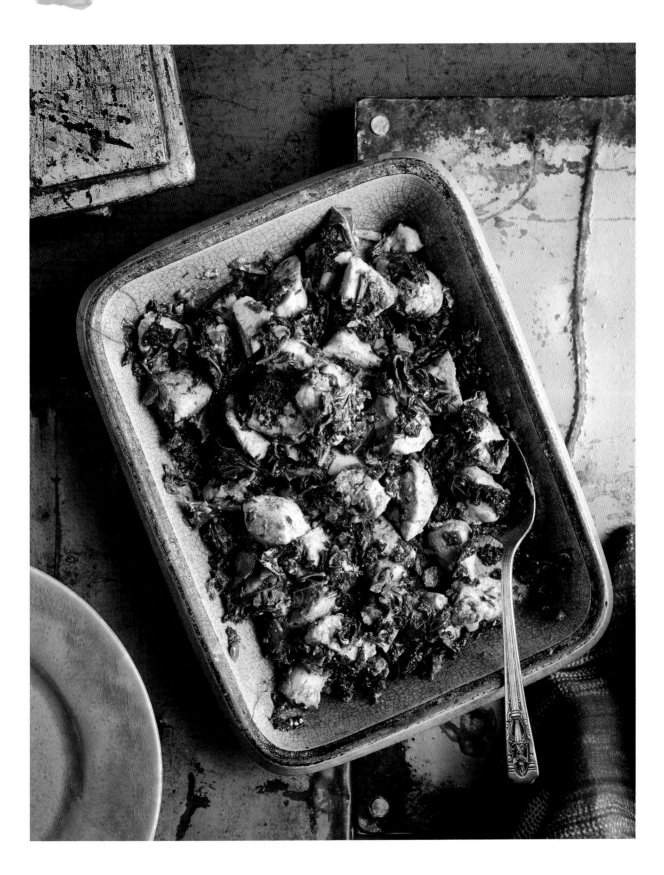

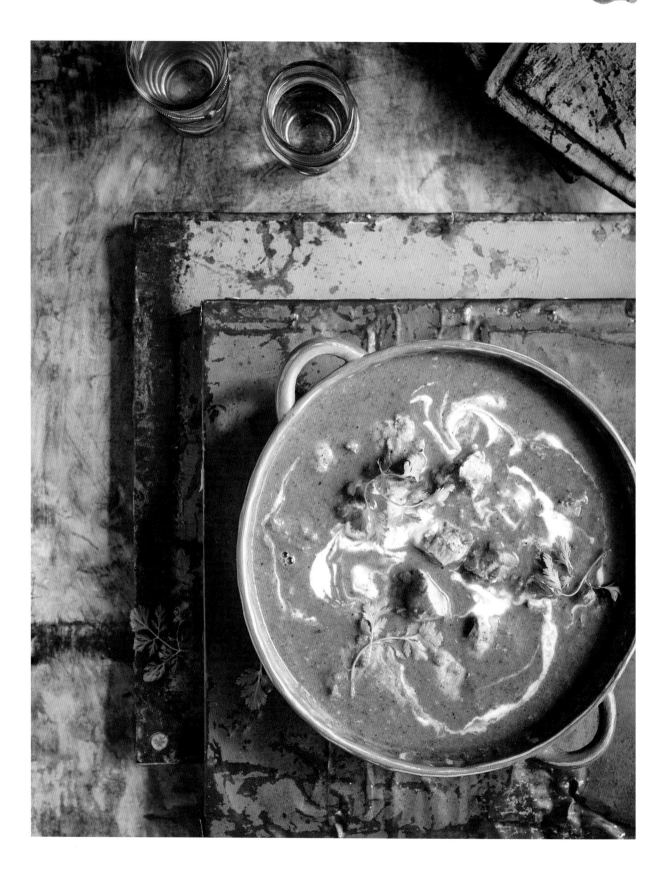

This comforting soup is wonderfully creamy, with warm and satisfying hits from coriander, cumin and, most importantly, fresh turmeric. When in season, fresh turmeric is available from many supermarkets and Indian grocery stores, and you may well be able to find it online. You could use ground turmeric for this recipe if you can't find fresh, but bear in mind its flavour is more powerful than that of fresh. The lentils and chicken work very well together, but if you prefer you can make a vegetarian version by omitting the chicken and doubling the quantity of lentils. And, as a change from soup, you could try this dish with rice and a dollop of yogurt on top.

Chicken, Lentil & Fresh Turmeric Soup

SERVES 4

1 tablespoon sunflower oil

1 tablespoon coriander seeds

1 tablespoon cumin seeds

1 teaspoon black peppercorns

10 curry leaves

2 red onions, roughly chopped

50g (1¾oz) fresh turmeric, peeled and roughly chopped (or use 1 tablespoon ground turmeric)

1cm (½ inch) piece of fresh root ginger, peeled and roughly chopped

4 garlic cloves, roughly chopped

3 tomatoes, roughly chopped

40g (1½oz) fresh coriander, leaves and stems roughly chopped, plus extra to garnish

1½ teaspoons salt

1 teaspoon honey

400ml (14fl oz) boiling water

400ml (14fl oz) can coconut milk

100g (3½oz) red lentils (massur dal)

500g (1lb 2oz) skinless chicken breast fillets, cut into 2.5cm (1 inch) dice

Heat the oil in a large saucepan over medium heat. Add the coriander and cumin seeds and the peppercorns and cook for a few seconds, then add the curry leaves and allow all the spices to sizzle for a few seconds more.

Mix in the onions and turmeric, then reduce the heat to medium–low and cook for 10 minutes, until the onions are lightly golden.

Stir the ginger and garlic into the saucepan and cook for 1 minute, then add the tomatoes and mix well. Increase the heat to medium and cook for 5 minutes, until the tomatoes have softened.

Throw in the fresh coriander and take the pan off the heat. Use a hand-held blender to blitz the mixture until smooth or, alternatively, transfer the mixture to a blender to process it, then return the soup to the pan.

Put the saucepan back over medium heat. Stir in the salt, honey, measured boiling water and three-quarters of the coconut milk. Now mix in the lentils and chicken. Cover the pan with a lid, reduce the heat to low and simmer for 15–20 minutes, until the lentils and chicken are both cooked. Sprinkle over the extra fresh coriander and drizzle with the remaining coconut milk before serving.

Basic Chapatti

Ginger & Garlic Gram Flour Puda

Fenugreek & Gram Flour Flatbreads

Pearl Millet & Potato Flatbreads

Moong Dal Khichdi

Tomato & Peanut Rice

Baked Chicken Biryani

Chicken & Egg Rice

Rice with All The Greens

Prawn Pulao

Mushroom & Red Onion Rice

Flatbreads & Rice

There are many different recipes for making chapatti, but this is the way my family has made them for generations. Our version is a healthy one – there is no added salt, oil or any other ingredient, just flour and water, which gives you perfect, simple chapatti that taste amazing. Use them to scoop up sabjis, curries, chutneys and pickles, and as wraps.

Basic Chapatti

MAKES 12

300g (10½oz) chapatti flour, plus extra for dusting
roughly 175ml (6fl oz) water
ghee, to serve

Put the flour into a bowl. Very slowly, mix in just enough of the measured water to bring the mixture together in a dough – you might not need all the water or you may need a little more, so add just a few drops at a time. This is the best way to achieve a dough that is the correct consistency: smooth but not sticky.

Once the dough has come together, knead it on a clean surface for 2 minutes. Leave it to rest, either in a covered bowl or an airtight box, for 15–20 minutes.

Divide the dough into 12 equal portions. Roll each portion into a ball in your hands, then roll each ball in a little flour to dust. Using a rolling pin, roll out each ball into a circle with a diameter of 15–18cm (6–7 inches).

Heat a skillet over medium heat until hot. Carefully transfer 1 rolled-out portion of dough to the hot skillet and cook it for a few seconds on the first side, then turn. Allow the chapatti to bubble up a little on the second side, which will only take a few seconds, then turn it over again and cook for a few seconds, until it is golden and cooked through, pressing gently on the edges with some kitchen paper or a clean tea towel, which encourages the flatbread to puff up a little. Transfer the chapatti to a serving plate and spread a tiny amount of ghee across the top surface. Keep hot while you repeat the process with the remaining portions of dough. The best way to keep your chapatti soft and warm until serving is to wrap them in foil or in a clean tea towel until ready to eat. Serve the chapatti hot.

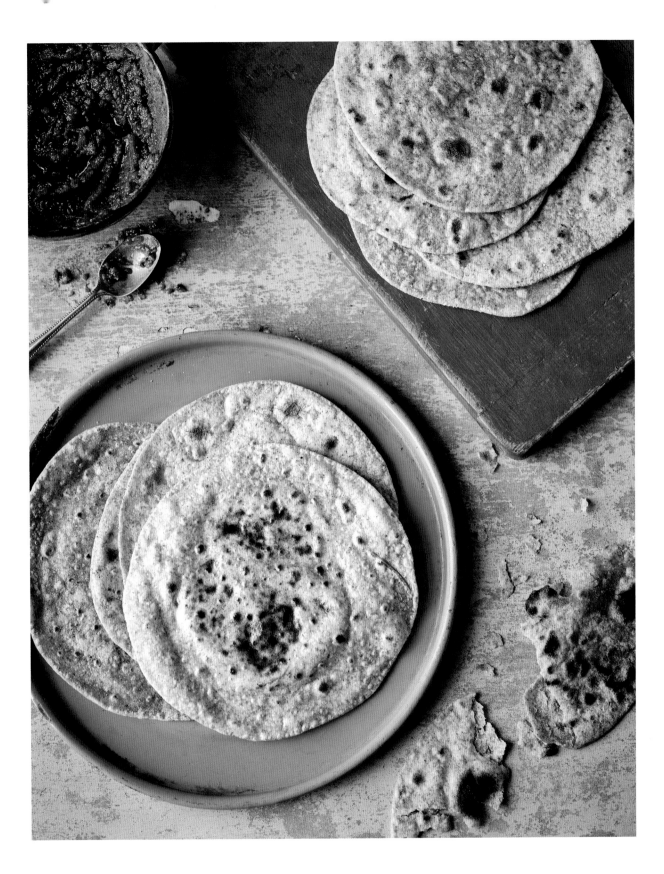

You can eat these delicious savoury pancakes for breakfast, lunch, dinner or anything in between. Gram flour makes a great base for all the spicy flavours I'm using here. Puda are best served with my Mango Pickle (*see* page 177) or a chutney (*see* pages 175, 176), but also make a good wrap with my Cumin Potatoes (*see* page 44) and Mango & Mint Chutney (*see* page 179).

Ginger & Garlic Gram Flour Puda

MAKES 4

150g (5½oz) gram (chickpea) flour

1 onion, finely chopped

2 garlic cloves, finely chopped

1cm (½ inch) piece of fresh root ginger, peeled and finely chopped

½ teaspoon carom seeds

½ teaspoon salt

½ teaspoon chilli powder

3 tablespoons finely chopped fresh coriander leaves

1 small green chilli, finely chopped

175ml (6fl oz) water

4 teaspoons sunflower oil

Combine all the ingredients, except the water and oil, in a large bowl. Stir in the measured water to produce a thin batter that will spread easily in the pan.

Select a frying pan with a diameter of around 25cm (10 inches). Heat ½ teaspoon sunflower oil in the pan over medium–low heat. Once hot, pour in one-quarter of the batter and use the back of a spoon to spread it across the surface of the pan. Cook for 2–3 minutes, until the underside is golden, then flip it over. Add another ½ teaspoon oil to the pan and cook for 2–3 minutes, until golden all over. Transfer the puda to a plate and cover with kitchen foil to keep warm while you cook the remaining batter in the same way. Serve warm.

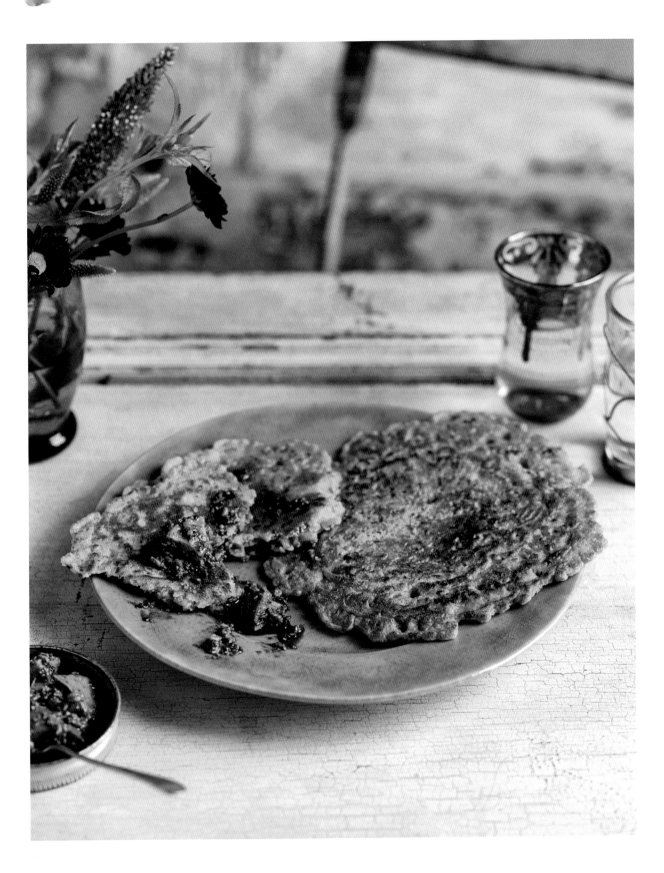

Flatbreads, also known as roti or chapatti, make a great accompaniment to any of the curries in this book. They are also terrific as a snack with some pickle or chutney, or used as wraps for your favourite fillings or some chutney and salad. They are handy to have for picnics and packed lunches, too. Have a go at making them – it's not difficult.

Fenugreek & Gram Flour Flatbreads

MAKES 10

150g (5½oz) chapatti flour, plus extra for dusting

50g (1¾oz) gram (chickpea) flour

2 tablespoons dried fenugreek leaves (kasuri methi)

2 tablespoons chopped fresh coriander leaves

½ teaspoon salt

½ teaspoon ground turmeric

½ teaspoon ground coriander

½ teaspoon garam masala

1 small green chilli, finely chopped

1 tablespoon ghee, plus extra for cooking

roughly 3–4 tablespoons water

Mix all the ingredients, except the water, in a large bowl. Very slowly add just enough of the measured water to bring the mixture together in a dough – you might not need all the water or you may need a little more, so add just a few drops at a time to ensure the dough is smooth but not sticky. Knead the dough for a minute or so. Cover and leave to rest for 15–20 minutes. (At this point, you can store the dough in the refrigerator for 4–5 days, ready to cook fresh roti whenever you like.)

Divide the dough into 10 equal pieces. Roll each piece into a ball with your hands and dust it with a little chapatti flour. Roll it out into a circle with a diameter of 17–20cm (6½–8 inches), which will give you a very fine roti with a thickness of roughly 1mm (1/32 inch).

Heat a skillet over high heat. Cook each roti for less than 1 minute on each side – as soon as the underside begins to turn golden, flip it over and, while the other side cooks, smear ¼ teaspoon ghee across the cooked top with the back of a spoon. When the underside is cooked, quickly toss again and smear ¼ teaspoon ghee over the side that is now facing up. Transfer to a serving dish and cover the dish with kitchen foil to keep the roti warm and soft while you cook the remaining dough circles in the same way. Serve hot.

A blend of flours combined with potato, spices and herbs produces these amazing flatbreads, which are great served simply with chutney or pickle, or alongside vegetable and lentil dishes. To make a gluten-free version, omit the self-raising flour and increase the quantity of millet flour to plug the gap – this makes the dough a little more difficult to roll out, so use your hands, rather than a rolling pin, to shape it into rounds and make the flatbreads a little thicker. Serve warm with some chutney or pickle or a side dish of your choice.

Pearl Millet & Potato Flatbreads

MAKES 8

100g (3½oz) pearl millet flour (bajra)

100g (3½oz) self-raising flour, plus extra for dusting

100g (3½oz) boiled potatoes, grated

¾ teaspoon salt

¾ teaspoon garam masala

¾ teaspoon mango powder (amchur)

2 tablespoons finely chopped fresh coriander leaves

roughly 150ml (¼ pint) water

4 tablespoons ghee

Mix the flours, grated potato, salt, garam masala, mango powder and coriander leaves in a large bowl. Very slowly mix in just enough of the measured water to bring the mixture together in a dough – you might not need all the water or you may need a little more, so add just a few drops at a time to ensure the dough is smooth but not sticky. The texture of millet flour is different to that of wheat flour, so ensure you add the water very slowly and keep mixing until you have a soft – but not wet – dough. Knead the dough for a minute or so, then cover it and leave it to rest for 15 minutes.

Heat a skillet over medium heat. Divide the dough into 8 equal portions, roll each portion into a ball with your hands and dust it with flour to prevent sticking. Using a rolling pin, roll out each ball into a circle with a diameter of 12–15cm (4½–6 inches), working carefully, as the dough will be crumbly.

Carefully transfer your first dough circle to the hot skillet and cook it over medium heat for 1 minute or so on each side, until golden. Now smear ¼ teaspoon ghee over the top-facing side and turn it over. Cook for a few seconds while you smear the other side with ¼ teaspoon ghee, then turn it over again and cook for a few more seconds to finish. Transfer to a serving plate and keep warm while you finish cooking the remaining dough circles in the same way. Serve warm.

We all know that comfort foods are often unhealthy, but this dish is classic comfort food, yet is very good for you and also seriously satisfying. It's easy to make, too, and you can incorporate all sorts of vegetables into it, so feel free to try it with anything you have in the refrigerator that you need to use up. Enjoy this khichdi with a little pickle and yogurt, or a light salad.

Moong Dal Khichdi

SERVES 4

1 tablespoon ghee

1 teaspoon cumin seeds

1 red onion, roughly chopped

1 medium potato, roughly chopped

1 carrot, roughly chopped

2 tomatoes, roughly chopped

2 cauliflower florets, cut into small pieces

1½ teaspoons salt

1 teaspoon garam masala

½ teaspoon chilli powder

¼ teaspoon freshly ground black pepper

100g (3½oz) split yellow moong lentils (moong dal)

150g (5½oz) basmati rice

1.2 litres (2 pints) water

Heat the ghee in a deep saucepan over medium–low heat. Add the cumin seeds and, after about 1 minute, once they start to pop, stir in the chopped onion, potato and carrot. Cook for 2 minutes, until they begin to soften. Next, add the tomatoes, cauliflower, salt and all the spices and mix well.

Stir the moong dal, rice and measured water into the saucepan. Bring the mixture to the boil, then cover the pan with a lid and cook over low heat for 20–25 minutes, until the rice and lentils are quite mushy. Serve immediately.

I hate wasting food, so I value recipes that give me an opportunity to use up leftover plain rice. This one produces a tasty rice dish that is great served with any dal or curry, or on its own with salad. The fresh tomatoes give it a lovely pop of colour, and their flavour goes really well with the crunchy peanuts.

Tomato & Peanut Rice

SERVES 4

300g (10½oz) uncooked or 900g (2lb) cooked basmati rice

1 tablespoon sunflower oil

1 teaspoon mustard seeds

1 tablespoon split chickpeas (chana dal)

10 fresh curry leaves

4 dried red chillies

75g (2¾oz) toasted peanuts, very lightly crushed using a pestle and mortar

1 large onion, finely chopped

4 tomatoes, roughly chopped

1 tablespoon tomato purée

1 tablespoon sambhar masala

1 teaspoon chilli powder

1 teaspoon salt

If you don't have any leftover rice to use up, cook your rice according to the packet instructions, then set it aside while you prepare the tomato mixture.

Heat the oil in a large saucepan over medium–low heat. Stir in the mustard seeds, chana dal, curry leaves, dried chillies and broken-up peanuts and let it all sizzle together for a few seconds. Mix in the chopped onion and cook for 6–7 minutes, until the onion begins to turn golden.

Meanwhile, blitz the chopped tomatoes to a pulp using a blender. Once the onion in the saucepan begins to colour, add the blitzed tomatoes and tomato purée. Mix well, then cover the pan with a lid, reduce the heat to low and cook for 12–15 minutes, until the sauce thickens.

Stir in the remaining spices and salt and cook for 1 minute. Finally, add the cooked rice and stir gently until thoroughly combined. Serve immediately.

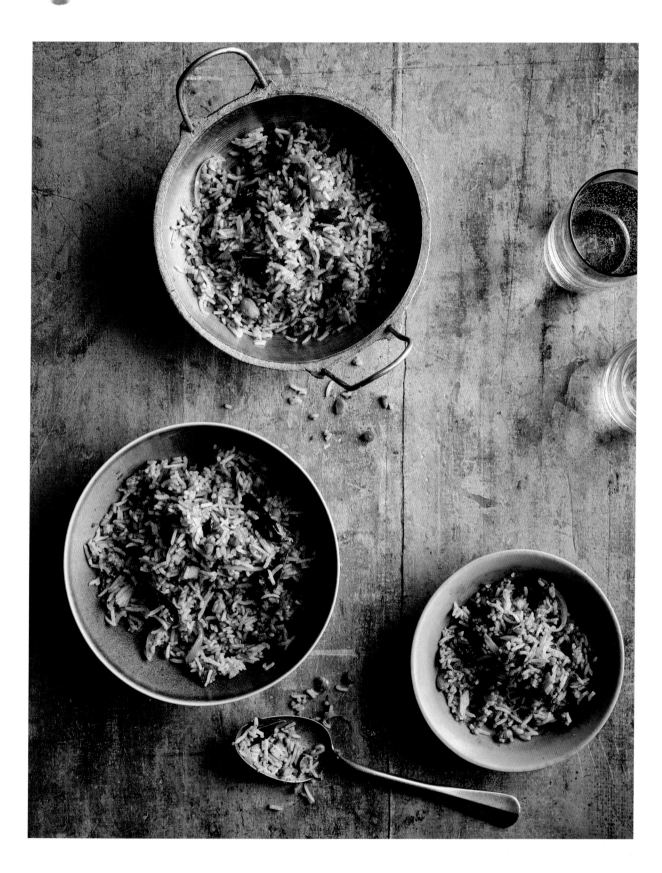

Don't be discouraged by the comparatively lengthy list of ingredients here, because this is actually quite an easy dish to make and it's a true crowd-pleaser – a firm family favourite in my home. I've combined some of my favourite versions of biryani into one simple, healthy recipe. Serve it warm with yogurt and chutney or a salad. You can bring the whole dish straight to the table and everyone can tuck in.

Baked Chicken Biryani

SERVES 6

1 whole skinless chicken, roughly 2kg (4lb 8oz)

450g (1lb) basmati rice

2.3 litres (4 pints) water

1 teaspoon salt

1 cinnamon stick

2 bay leaves

6 cloves

6 green cardamom pods

1 teaspoon cumin seeds

2 pinches of saffron threads

2 tablespoons warm milk

2 tablespoons sunflower oil, plus extra for greasing

4 red onions, thinly sliced

½ teaspoon kewra water or rose water

For the marinade

200ml (7fl oz) natural yogurt

1 teaspoon garam masala

1½ teaspoons salt

1 teaspoon ground turmeric

1 teaspoon Kashmiri chilli powder

½ teaspoon ground cinnamon

½ teaspoon ground cardamom

4 garlic cloves, grated

2.5cm (1 inch) piece of fresh root ginger, peeled and grated

1 small green chilli, finely chopped

Cut the chicken into similar-sized pieces with a length of roughly 5–8cm (2–3¼ inches) and put them into a large bowl. Mix all the marinade ingredients together in a separate bowl and pour the mixture over the chicken. Mix to coat the chicken pieces well. Cover the bowl and set aside to marinate, which you can do at room temperature for 2 hours or overnight in the refrigerator.

Rinse the rice in cold water and then drain it. Repeat this 4 or 5 times, until the water remains clear.

Put the measured water into a large saucepan with the salt, cinnamon stick, bay leaves, cloves, cardamom pods and cumin seeds. Bring the water to the boil, then add the rice. Reduce the heat to low and cook for 15 minutes, until the rice is three-quarters of the way towards being cooked – it's important not to allow it to fully cook at this stage. Drain the rice.

Meanwhile, soak the saffron in the milk in a small bowl for 15–20 minutes. While the saffron is soaking, heat the sunflower oil in a saucepan over medium–low heat and add the sliced onions. Cook for 10 minutes, until golden. Preheat the oven to 180°C (350°F), Gas Mark 4.

Select an ovenproof dish about 5cm (2 inches) deep. Add a few drops of oil and spread it around with your hands to lightly grease the dish. Lay the marinated chicken pieces in the dish in a single layer. Sprinkle over half the fried onions. Spread the rice on top, picking out the larger whole spices as you go. Sprinkle over the remaining onions, then the kewra water or rose water, then the saffron milk.

Cover the dish tightly with kitchen foil and bake for 40–45 minutes or until the chicken is cooked through. Let the dish sit undisturbed for 10 minutes after taking it out of the oven before serving.

Another great recipe for when you have some leftover cooked rice in your refrigerator. This delicious and perennially popular combination of chicken and rice is the ideal easy midweek meal. Any leftovers can go straight into a lunchbox for the next day.

Chicken & Egg Rice

SERVES 4

300g (10½oz) uncooked or 900g (2lb) cooked basmati rice

400g (14oz) skinless, boneless chicken thighs, cut into 1cm (½ inch) dice

1 tablespoon sunflower oil

1 onion, finely chopped

10 spring onions, thinly sliced

3 large eggs, beaten

1 tablespoon chilli sauce

1 tablespoon tomato ketchup

1 tablespoon dark soy sauce

½ teaspoon salt

¼ teaspoon freshly ground black pepper

For the marinade

¼ teaspoon salt

¼ teaspoon freshly ground black pepper

¼ teaspoon ground turmeric

1 teaspoon dark soy sauce

If you are using uncooked rice, cook it according to the packet instructions, then leave it to cool.

Meanwhile, marinate the chicken pieces. Put them into a bowl, add the marinade ingredients and give everything a good stir. Leave to marinate for 15 minutes.

Heat the oil in a saucepan over medium–low heat. Add the onion and cook for 2 minutes, until it begins to soften. Now stir in the spring onions, reduce the heat to low and cook for 5 minutes or until softened.

Add the marinated chicken, increase the heat to medium and cook, stirring often, for 6–8 minutes, until the chicken is cooked through.

Increase the heat to high and pour in the beaten eggs. Cook, stirring continuously, for 2 minutes, until the eggs are scrambled.

Add the chilli sauce, ketchup, soy sauce, salt and pepper to the pan and mix well. Stir in the cooked rice and, once all the ingredients are well combined, cook for a further 2 minutes. Serve immediately.

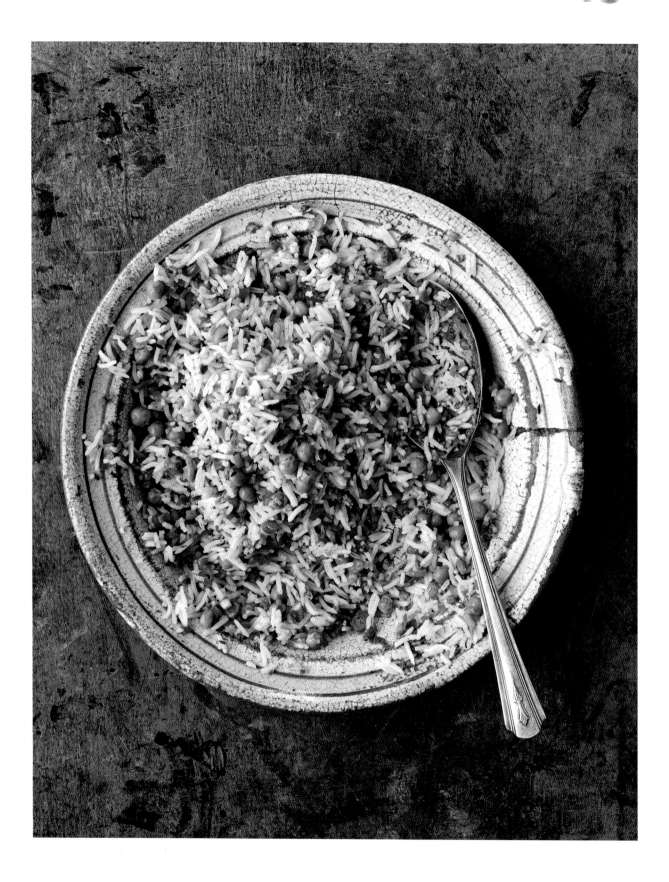

This fresh and light dish can be ready in minutes if you're using leftover cooked rice to make it. You'll love how the garam masala and black pepper give warmth to the crisp green veg. Paired with chutney or pickle, or served with just a dollop of natural yogurt, this meal is one I always find inviting – it's really delicious! But it's perfect, too, with dal or Chicken & Potato in Pickling Spices (*see* page 133).

Rice with All The Greens

SERVES 4

300g (10½oz) uncooked or 900g (2lb) cooked white rice

1 tablespoon sunflower oil

1 teaspoon cumin seeds

2 garlic cloves, finely chopped

8 spring onions, finely chopped

100g (3½oz) sugar snap peas, finely chopped

100g (3½oz) fine green beans, finely chopped

100g (3½oz) fresh or frozen peas

1 teaspoon salt

1 teaspoon garam masala

¼ teaspoon freshly ground black pepper

½ teaspoon chilli powder

If you don't have any leftover rice to use up, cook your rice according to the packet instructions and set aside.

Heat the oil in a large saucepan over low heat. Add the cumin seeds and let them sizzle for a few seconds, then stir in the garlic. Cook for 1 minute, then mix in the spring onions, sugar snap peas, green beans and peas. Cover the pan with a lid and cook for 5–6 minutes, until the greens are tender but still have a bit of crunch.

Add the salt, garam masala, pepper and chilli powder to the saucepan and mix well. Throw in the cooked rice and toss gently to combine. Serve warm.

If you love seafood with rice, this recipe is for you – a heavenly bowl of spicy, fragrant prawn rice. With a spoonful of yogurt, it makes a quick and easy midweek meal, served with raita and salad, but it's terrific as part of a feast, too.

Prawn Pulao

SERVES 4

1½ tablespoons sunflower oil

2 bay leaves

4 green cardamom pods

I star anise

I cinnamon stick

I large onion, finely chopped

Icm (½ inch) piece of fresh root ginger, peeled and finely chopped

4 garlic cloves, finely chopped

I small green chilli, finely chopped

2 tomatoes, finely chopped

I teaspoon salt

½ teaspoon chilli powder

I teaspoon ground turmeric

I teaspoon garam masala

½ teaspoon freshly ground black pepper

16 raw king prawns, shelled and deveined

300g (10½oz) basmati rice

700ml (1¼ pints) boiling water

20g (¾oz) mint leaves, finely chopped

20g (¾oz) fresh coriander, leaves and stems finely chopped

Heat the oil in a large saucepan over medium–low heat. Add the bay leaves, cardamom pods, star anise and cinnamon stick and cook for a few seconds, then add the onion and cook over medium heat for 5 minutes, until the onion begins to colour.

Stir the ginger, garlic and green chilli into the saucepan and cook for 1 minute, then mix in the tomatoes. Reduce the heat to low and simmer for 8–10 minutes, until the tomatoes have softened.

Add the salt and dry spices to the saucepan and mix well. Stir in the prawns, then the rice, and then the measured boiling water. Add the mint and coriander leaves, reserving a little of each to garnish the dish.

Cover the saucepan with a lid and cook over low heat for 15–20 minutes, until the rice is cooked. Ensure you don't lift the lid during the cooking time, to avoid losing the steam. Sprinkle over the reserved herbs and serve immediately.

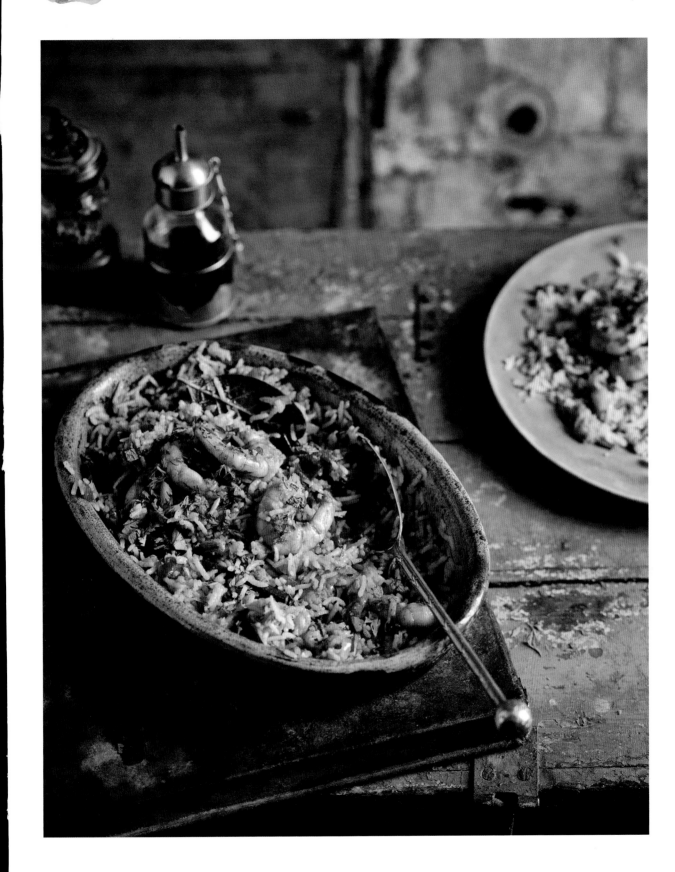

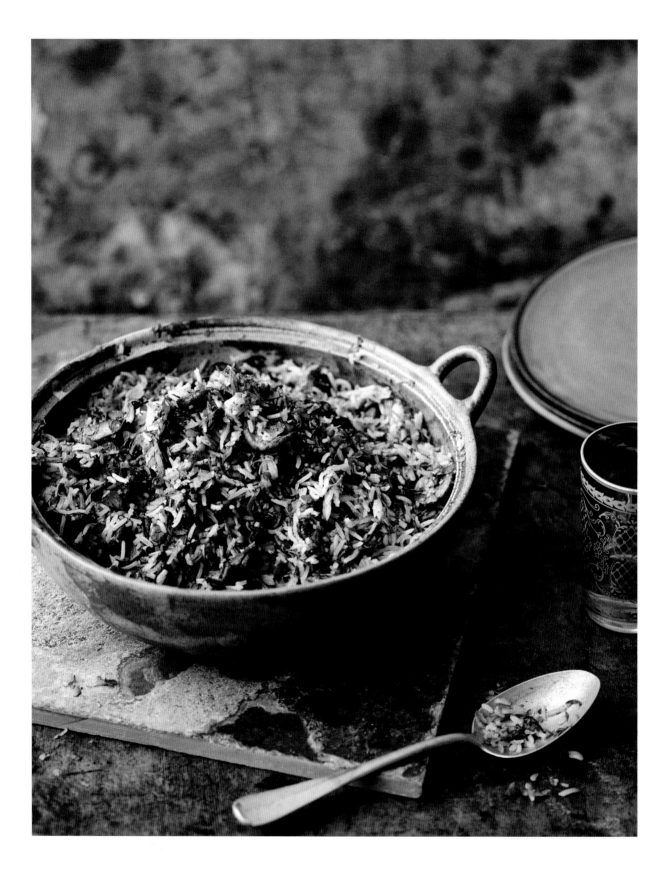

Mushroom, onion and garlic cooked together is a wonderful combination – and even better when mixed into rice. This recipe provides a great way of using up leftover rice. Raita and salad are all that's needed to make it a complete meal.

Mushroom & Red Onion Rice

SERVES 4

300g (10½oz) uncooked or 900g (2lb) cooked white rice

1 tablespoon sunflower oil

2 red onions, thinly sliced

4 garlic cloves, finely chopped

1 small green chilli, finely chopped

300g (10½oz) chestnut mushrooms, thinly sliced

2 teaspoons salt

1 teaspoon garam masala

½ teaspoon chilli powder

40g (1½oz) fresh coriander, leaves and stems finely chopped

If you don't have any leftover cooked rice to use up, cook your rice according to the packet instructions. Set aside to cool.

Heat the oil in a large saucepan over medium–low heat. Add the onions and cook for 4–5 minutes, until softened. Add the garlic and chilli and cook for 2 minutes more, then stir in the mushrooms. Cover the pan with a lid and cook for 5 minutes, until the mushrooms are soft.

Take the lid off the pan, increase the heat to high and cook for 2 minutes, until the excess water has evaporated. Add the salt, garam masala and chilli powder and mix well. Stir in the coriander, then the cooked rice. When thoroughly combined, cook until the rice is heated through. Serve immediately.

Garlic Pickle

Tomato, Garlic & Chilli Chutney

Ginger & Tamarind Chutney

Mango Pickle

Mango & Mint Chutney

Aubergine Pickle

Carrot & Onion Pickle

Chutneys & Pickles

Almost any Indian dish can be paired with this delicious, strongly flavoured pickle, which has a pleasing smoky hint and a good chilli hit. Whether you serve it alongside lentils, chicken, fish or veg, it's bound to make the meal more special.

Garlic Pickle

MAKES ROUGHLY 250G (9OZ)

40 garlic cloves, peeled
2 tablespoons mustard oil
10 small green chillies, quartered lengthways
1 teaspoon salt
1 teaspoon chilli powder
1 teaspoon ground turmeric
1 tablespoon grated or roughly chopped jaggery

For the spice blend
2 teaspoons fenugreek seeds
2 teaspoons black mustard seeds
2 teaspoons cumin seeds
2 teaspoons coriander seeds

First, make the spice blend. Heat a dry frying pan over low heat. Add the seeds and toast them for about 2 minutes, until they are fragrant and you can see them starting to smoke – but don't let them colour or burn! Use a pestle and mortar to grind the toasted seeds to a rough powder. Set aside.

Chop any really large garlic cloves lengthways into smaller pieces so that all the pieces of garlic are of a similar size.

Heat the oil in a saucepan over low heat. When it is smoking hot, add the garlic and green chillies and cook for 5–7 minutes, until the garlic begins to soften but doesn't colour.

Add the spice blend along with the salt, chilli powder, turmeric and jaggery. Mix well and cook for 2 minutes, until the jaggery has melted.

Spoon the mixture into a sterilized jar and seal well. Leave the pickle to mature in a warm place for 1 week before serving. Once the jar is open, it will keep well in the refrigerator for up to 3 months.

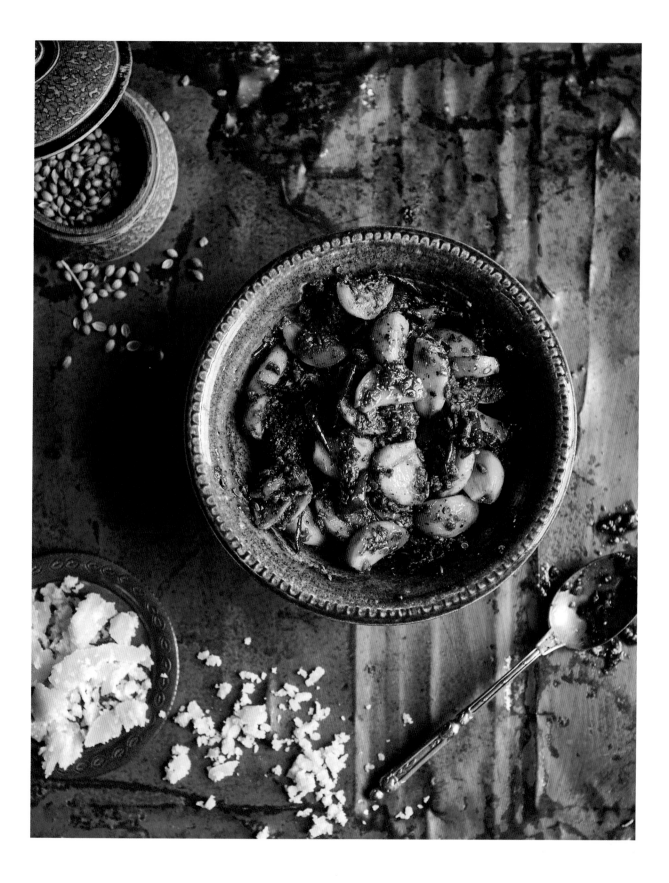

Curry leaves add the wow factor in this super-delicious, intensely flavoured chutney. I think it's brilliant with any meal, but it's especially good alongside lentil dishes.

Tomato, Garlic & Chilli Chutney

MAKES ROUGHLY 200G (7OZ)

10 dried red chillies
2 tomatoes
6 garlic cloves
1 tablespoon sunflower oil
1 teaspoon black mustard seeds
pinch of asafoetida
10 fresh curry leaves
4 teaspoons water
½ teaspoon salt
1 teaspoon caster sugar

Soak the chillies in water for 1 hour. Drain them, then put them into the bowl of a food processor with the tomatoes and garlic and blitz until smooth. Set aside.

Heat the oil in a saucepan over medium–low heat. Add the mustard seeds and asafoetida and let them sizzle for a few seconds, then stir in the curry leaves and cook for a few seconds more.

Mix the puréed tomato and the measured water into the saucepan. Bring to the boil, then reduce the heat to low and cook for 10–15 minutes, until the garlic and tomatoes have lost their raw taste and the chutney has thickened slightly.

Take the pan off the heat and stir in the salt and sugar. Leave to cool before serving. This chutney will keep in an airtight container in the refrigerator for 9–10 days.

This smooth chutney is sweet, spicy and sour all at the same time, with a beautifully strong ginger flavour. It works well with any of the recipes in this book, whether rice, flatbreads or curry.

Ginger & Tamarind Chutney

MAKES ROUGHLY 200G (7OZ)

1 tablespoon split chickpeas (chana dal)
1 tablespoon split black lentils (urad dal)
1 tablespoon sunflower oil
pinch of asafoetida
1 teaspoon black mustard seeds
1 teaspoon cumin seeds
6 dried red chillies
4 tablespoons water
100g (3½oz) fresh root ginger, peeled and finely chopped
½ teaspoon salt
1 tablespoon tamarind paste
2 tablespoons grated or chopped jaggery

Soak both types of dal in a bowl of water for 1 hour. Drain and set aside.

Heat the oil in a saucepan over medium heat. Add the asafoetida and the mustard and cumin seeds and let them sizzle for a few seconds. Stir in the dried red chillies, the dals and the measured water. Cover the pan with a lid, reduce the heat to low and cook for 10 minutes, until the lentils begin to soften.

Stir the ginger into the saucepan and cook for 5 minutes, until the ginger begins to turn golden. Finally, stir in the salt, tamarind and jaggery and mix well.

Immediately transfer the mixture to a blender and blitz until smooth. The chutney will keep in an airtight container in the refrigerator for 7–10 days.

This pickle is spicy, sour and has a real bite to it. It pairs wonderfully with all sorts of dishes, especially lentils, flatbreads and rice.

Mango Pickle

**MAKES ROUGHLY
600G (1LB 5OZ)**

30g (1oz) black mustard seeds

20g (¾oz) fennel seeds

10g (¼oz) fenugreek seeds

100ml (3½fl oz) mustard oil

½ teaspoon asafoetida

80g (2¾oz) salt

20g (¾oz) chilli powder

10g (¼oz) ground turmeric

500g (1lb 2oz) green or unripe mangoes, unpeeled and cut into 2.5cm (1 inch) dice

Heat a saucepan over low heat and add the black mustard, fennel and fenugreek seeds. Toast them for 2 minutes or until fragrant. Tip the seeds into a mortar and use the pestle to crush them just until they open up – you don't need a fine powder. Set aside.

Heat the oil in the same saucepan you used to toast the seeds over medium heat until smoking hot. Take the pan off the heat and add the asafoetida, which will sizzle. Let it cool slightly for 15 minutes or so.

Add the crushed spices, salt, chilli powder and turmeric to the oil in the saucepan and mix well.

Put the mango dice into a bowl and pour over the spiced oil. Mix well. Cover the bowl and leave it in the sunshine or a warm place in your kitchen for 1 week to mature. Then transfer the pickle to a sterilized jar and store it in the refrigerator for up to 3 months.

I love a good, herby, fresh green chutney and this one goes with almost any meal you might cook from this book. Using green mango adds a tangy flavour and a lovely summery note. If you can't find any small green mangoes, go for a big, really hard, unripe mango from the supermarket, which will work just as well.

Mango & Mint Chutney

MAKES ROUGHLY 200G (7OZ)

100g (3½oz) green or unripe mango, peeled and diced
40g (1½oz) mint, leaves picked
40g (1½oz) fresh coriander
½ teaspoon salt
½ teaspoon sugar
2 small green chillies
1 tablespoon lime juice
4 tablespoons water

Put all the ingredients into the bowl of a mini food processor. Whizz until smooth. Serve immediately.

This chutney will keep in an airtight container in the refrigerator for 4–5 days.

This is my new favourite pickle! Although it's very different to the usual Indian relish, it goes well with any of the dishes in this book. The aubergine strips soak up all the flavours of the garlic, ginger, spices and – best of all – tamarind, which gives the pickle a tasty sour kick.

Aubergine Pickle

MAKES ROUGHLY 175G (6OZ)

1 aubergine, roughly 400g (14oz)

2 teaspoons salt

2 tablespoons mustard oil

¼ teaspoon asafoetida

40g (1½oz) fresh root ginger, peeled and ground to a paste

40g (1½oz) garlic cloves, ground to a paste

1 tablespoon black mustard seeds

1 teaspoon fenugreek seeds

4 dried red chillies

1 tablespoon tamarind paste

1 teaspoon caster sugar

Using a very sharp knife, such as a filleting knife, cut the aubergine into fine strips that are roughly 5mm (¼ inch) thick and 3–4cm (1¼–1½ inches) long. Sprinkle the strips with the salt and mix well. Put them into a colander and leave to rest on your draining board for a couple of hours. Once the salting time has elapsed, squeeze out all the liquid from the aubergine using your hands. Spread out the slices on a clean tea towel or kitchen paper and set aside.

Heat the oil in a wide frying pan over high heat until it is smoking hot, then add the asafoetida and let it sizzle for a few seconds. Reduce the heat to medium, add the aubergine and cook for 5 minutes, turning once, until the strips are light golden.

Reduce the heat under the frying pan to low, add the ginger and garlic pastes and cook for 8–10 minutes so that the garlic and ginger cook but don't brown, as this will make them bitter.

Meanwhile, in a small frying pan, toast the mustard and fenugreek seeds and dried chillies over medium–low heat for a couple of minutes, until they begin to change colour and are smoky and fragrant. Lightly crush the toasted seeds and chillies using a pestle and mortar, ensuring the mixture retains a little texture and crunch.

Tip the ground spices into the frying pan with the aubergine strips and cook for 1 minute, then add the tamarind and sugar. Mix well, then take the pan off the heat and leave the mixture to cool. Once cool, pack the pickle into a sterilized jar. Store in the refrigerator for 10–15 days.

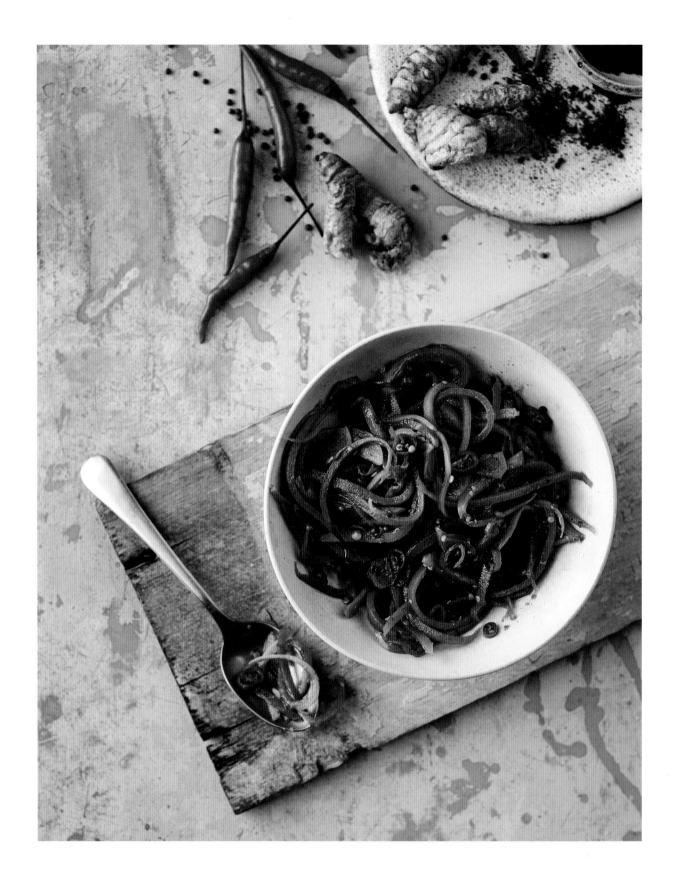

You'll love this crunchy, fresh and spicy pickle. Serve it with any of the dishes in this book, but it's especially good with rice and lentils.

Carrot & Onion Pickle

**MAKES ROUGHLY
600G (1LB 5OZ)**

2 carrots, cut into strips

2 red onions, thinly sliced

12 small green chillies, thinly sliced

2 pieces of fresh turmeric, peeled and thinly sliced

1 teaspoon salt

½ teaspoon chilli powder

2 teaspoons black mustard seeds, lightly crushed

150ml (¼ pint) cider vinegar

Mix all the ingredients together in a large bowl, ensuring they are well combined.

Pack the mixture into a sterilized jar and leave in a dark place for 24 hours. Transfer the jar to the refrigerator after that, where it will keep for 7–10 days.

Walnut & Hazelnut Laddoos

Saffron Yogurt

Coconut Barfi

Mango, Lime & Coconut Panna Cotta

Nutty Spicy Chocolate Bark

Date & Cardamom Kheer, Three Ways

Chana Dal & Almond Barfi

Sweets

Nuts add such a lovely flavour to these laddoos, and also help to bind them so they hold their shape well. Quick and simple to make, these tempting treats are scented with cardamom and also rose water, which adds a delicate, heart-warming floral touch. Laddoos are a great sweet with which to end a meal, but I warn you – it is difficult to stop at just one.

Walnut & Hazelnut Laddoos

MAKES 15

85g (3oz) walnuts
85g (3oz) hazelnuts
150g (5½oz) chapatti flour
3 tablespoons ghee
3 tablespoons agave nectar
1 teaspoon ground cardamom
¼ teaspoon rose water
dried rose petals, to decorate

Put the nuts into a dry frying pan over medium–low heat and toast them, stirring continuously, for 5 minutes or until they change colour.

Tip the toasted nuts into a mini food processor and blitz to a paste – keep blending until the nuts release their oil. Transfer the nut paste to a bowl.

Put the flour into the same dry frying pan and toast it over low heat for 8–10 minutes, stirring continuously, until the flour is light golden and fragrant. Add the ghee and mix well – the mixture will start to look crumbly.

Add the flour mixture to the nut paste along with the agave nectar, cardamom and rose water. Use your hands to combine the mixture well.

Take a lime-sized portion of the laddoo mixture in the palm of your hand and compress it into a small ball. Set the laddoo on a serving dish and repeat the shaping process with the remaining mixture.

You can serve the laddoos immediately, decorated with dried rose petals, or store them in an airtight container in the refrigerator for 5–6 days. Bring them to room temperature before serving.

Plain yogurt really comes to life with the addition of saffron and a mix of crisp, sweet, fresh fruits. The yogurt here is hung in a muslin cloth overnight to drain the excess liquid. The result is thick and deliciously rich.

Saffron Yogurt

SERVES 4

400ml (14fl oz) natural yogurt
pinch of saffron threads
1 tablespoon warm milk
2 tablespoons icing sugar
1 apple, finely chopped
1 banana, finely chopped
10 red grapes, thinly sliced
handful of pomegranate seeds

Line a sieve with a clean muslin cloth, then pour the yogurt into it. Gather up the ends of the fabric and tie them into a knot, making a loop at the top. You can hang the parcel in a large, deep saucepan. Insert a wooden spoon handle or something similar through the loop, then rest the handle across the top of the pan so the parcel hangs from the handle inside the pan without touching the base, allowing the excess liquid to drain from the parcel into the pan. Transfer the pan to the refrigerator and leave to drain overnight.

Next day, steep the saffron in the warm milk for 5 minutes.

Tip the hung yogurt into a bowl and add the saffron milk and icing sugar. Stir thoroughly until smooth.

Add most of the prepared fruit to the saffron yogurt, reserving a little for decoration. Mix well. Serve immediately in small bowls, with the reserved fruit arranged on top.

Also known as laddoo, this chewy sweet gets its unique texture from fresh, finely ground coconut. The addition of jaggery not only sweetens the mixture but helps it stick together. Pretty pistachios provide a lovely crunchy finish.

Coconut Barfi

MAKES 15–20 PIECES

150g (5½oz) fresh coconut
50g (1¾oz) semolina
100g (3½oz) jaggery, grated
1 tablespoon ghee, plus extra for greasing
½ teaspoon ground cardamom
20g (¾oz) finely chopped pistachio nuts

Blitz the fresh coconut using a mini food processor until it resembles desiccated coconut.

Put a dry saucepan over low heat. Add the semolina and toast it for 2 minutes, stirring constantly, until it has a toasty fragrance and is just beginning to change colour.

Add the coconut, jaggery and ghee to the saucepan and mix well. Cook over low heat for 10–12 minutes, until the jaggery has melted. Stir in the cardamom.

Grease a 17–18cm (6½–7 inch) square cake tin with ghee. Tip the coconut mixture into it and spread it out evenly. Press down on the mixture with a spatula or your hands and smooth the surface. Sprinkle the pistachios across the surface and press them in gently. Leave to cool for 10 minutes.

Turn out the barfi on to a chopping board and cut it into 15–20 pieces. Serve them with the pistachio-sprinkled sides facing up.

Some of my favourite flavours combine beautifully in this simple but outstanding dessert. It's not too sweet, and yet it never fails to please, thanks to the mango purée and lime zest.

Mango, Lime & Coconut Panna Cotta

MAKES 5

3 gelatine leaves
200ml (⅓ pint) milk
200ml (⅓ pint) double cream
100ml (3½fl oz) coconut cream
1 teaspoon vanilla extract
finely grated zest of 2 limes
30g (1oz) caster sugar
85g (3oz) Alphonso mango purée
1 mango, diced, to decorate

Put the gelatine into a bowl of cold water and set aside to soak.

Combine the milk, double cream, coconut cream and vanilla in a saucepan and bring to a simmer over low heat. As soon as the mixture begins to bubble, take it off the heat and add half the lime zest and the sugar. Whisk well to dissolve the sugar.

Squeeze the water from the gelatine leaves and add them to the hot cream mixture. Whisk again until the gelatine dissolves, then add the mango purée and whisk again.

Pour the mixture into 5 ramekins, then transfer to the refrigerator and leave to set for 2–3 hours.

Turn out the panna cottas on to serving plates. Top with the fresh mango, sprinkle over the remaining lime zest and serve chilled.

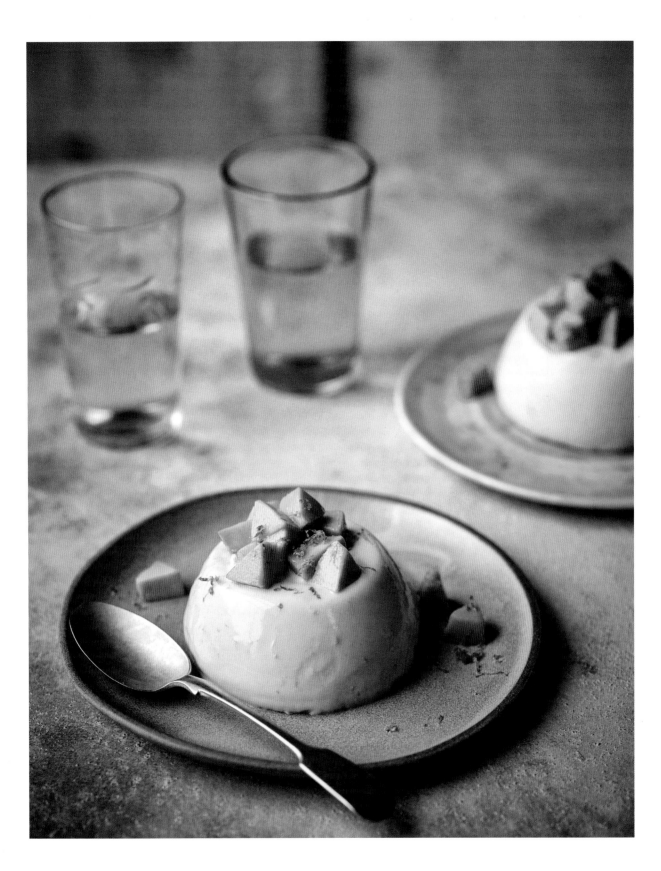

Delicious dark chocolate receives a lovely boost from this mix of nuts, dried fruit and spices, which adds satisfying crunch and some lovely tropical flavours. Serving this as dessert is the perfect way to end a meal. I bet you'll go back for a second helping!

Nutty Spicy Chocolate Bark

SERVES 6–8

sunflower oil, for greasing
20g (¾oz) cashew nuts
20g (¾oz) almonds
20g (¾oz) pistachio nuts
20g (¾oz) sultanas
200g (7oz) dark chocolate, broken into small pieces
½ teaspoon ground cardamom
½ teaspoon ground cinnamon

Lightly grease a baking tray and line it with some baking paper.

Put the nuts and sultanas into the bowl of a mini food processor and pulse to roughly chop them. (Alternatively, roughly chop them by hand.)

To melt the chocolate pieces, put them into a heatproof bowl set over a saucepan of gently simmering water, ensuring the water does not touch the base of the bowl. Once the chocolate has melted, remove the bowl from the heat and stir in the ground cardamom and cinnamon.

Pour half the melted chocolate into the prepared tray and spread it out evenly, using a spatula, into a square measuring roughly 20 × 20cm (8 × 8 inches). Sprinkle evenly with half the nut mixture. Drizzle over the remaining chocolate to cover the nuts, then sprinkle over the remaining nut mixture. Refrigerate for 30 minutes or until completely set.

Break the sheet of chocolate into jagged pieces to serve. In the freak event of having any pieces left over, store them in the refrigerator.

The cardamom intensifies the sweetness and flavour of the dates and maple syrup in this delicious dessert. It's one of my favourite puddings from my childhood, and one I love to make for my family to this day. You can enjoy this sweet dish hot or cold, and you can add a topping for an extra-special touch.

Date & Cardamom Kheer, Three Ways

SERVES 6

100g (3½oz) basmati rice
1.2 litres (2 pints) milk
10 green cardmom pods, seeds crushed to a powder
100g (3½ oz) Medjool dates, finely chopped
1 tablespoon maple syrup

Soak the rice in water for 1 hour, then drain and rinse it. Using a pestle and mortar, crush the grains into small pieces. Set aside.

Put the milk into a saucepan over medium heat and bring it to scalding point, then reduce the heat to low to prevent it from boiling over. Mix in the cardamom seed powder, then add the crushed rice. Cook over very low heat for 20 minutes, until the rice begins to soften.

Stir in the chopped dates, then cook over low heat for 1 hour 10 minutes, until the rice is cooked, stirring every 10 minutes to ensure the rice doesn't stick to the base of the pan and scorch it.

Add the maple syrup to the saucepan and mix well. Now take the pan off the heat and serve warm, or leave to cool, then refrigerate and serve chilled with the topping of your choice.

1 with mango
2 with strawberries
3 with pistachios & almonds

Date & Cardamom Kheer, Three Ways

1

with mango

1 mango

Position the mango with the ends pointing away from and towards you. Use a serrated knife to slice off each mango cheek. Score a criss-cross pattern into the flesh of each mango cheek then press the skin of the cheek to push out the squares of flesh. Cut away the cubes of flesh and scatter them over the kheer.

2

with strawberries

16 strawberries

Use a paring knife to hull the
strawberries. Cut them into halves or
quarters and scatter over the kheer.

3

with pistachios
& almonds

handful of chopped pistachio nuts
handful of almonds, thinly sliced

Scatter the chopped pistachios and sliced
almonds artfully over the kheer.

Barfi is a very popular sweet, often made with nuts, milk and lots of sugar. This lovely version uses chana dal for a thick, creamy base. Cardamom and dates add lots of flavour and sweetness, while chopped almonds bring a welcome crunch.

Chana Dal & Almond Barfi

MAKES 12 PIECES

100g (3½oz) split chickpeas (chana dal)

150ml (¼ pint) water

115g (4oz) dried dates

4 tablespoons warm milk

200ml (⅓ pint) chilled milk

2 tablespoons ghee, plus extra for greasing

50g (1¾oz) almonds, finely chopped

10 green cardamom pods, seeds ground to a powder

1 tablespoon maple syrup

2–3 sheets of edible silver leaf or 12 almonds, to decorate

Soak the chana dal in the measured water for 1 hour. Meanwhile, soak the dates in the warm milk for 1 hour.

Rinse the dal then tip it into the bowl of a food processor. Add the chilled milk and blitz the mixture to a smooth paste.

Heat a large saucepan over low heat and add the ghee. Once it is hot, add the dal paste and cook for 40–45 minutes, stirring vigorously every 5–7 minutes. Expect the paste to come away from the sides of the pan and to become thick and gloopy during cooking. Continue to cook until the texture of the paste becomes a little crumbly.

Blitz the dates along with their soaking milk using a blender. Add the mixture to the dal and cook for a further 15 minutes over low heat, stirring every 5 minutes, until the ingredients are well combined.

Meanwhile, toast the chopped almonds in a dry frying pan, stirring often, for about 5 minutes, until they just begin to colour. Set aside.

Use a little ghee to grease a shallow cake tin or a brownie tray that measures roughly 20 × 25cm (8 × 10 inches).

Stir the cardamom powder and maple syrup into the mixture in the saucepan, then add the toasted chopped almonds.

Tip out the barfi mixture into the prepared tray. Spread it out and level off the surface using a spatula or the back of a spoon. Press down on it with your hands to compress the mixture – it should be about 1.5cm (⅝ inch) thick. Leave it to cool completely.

Flip out the barfi on to a chopping board. If decorating with silver leaf, you'll need to brush any area on which you intend to apply it with a tiny drop of water first, so that the silver leaf will adhere to the surface. Then use tweezers or the tip of a sharp knife to arrange the pieces of silver leaf on the surface. Cut the barfi into 12 squares with a greased knife. If using almonds to decorate, press 1 almond into the centre of each square.

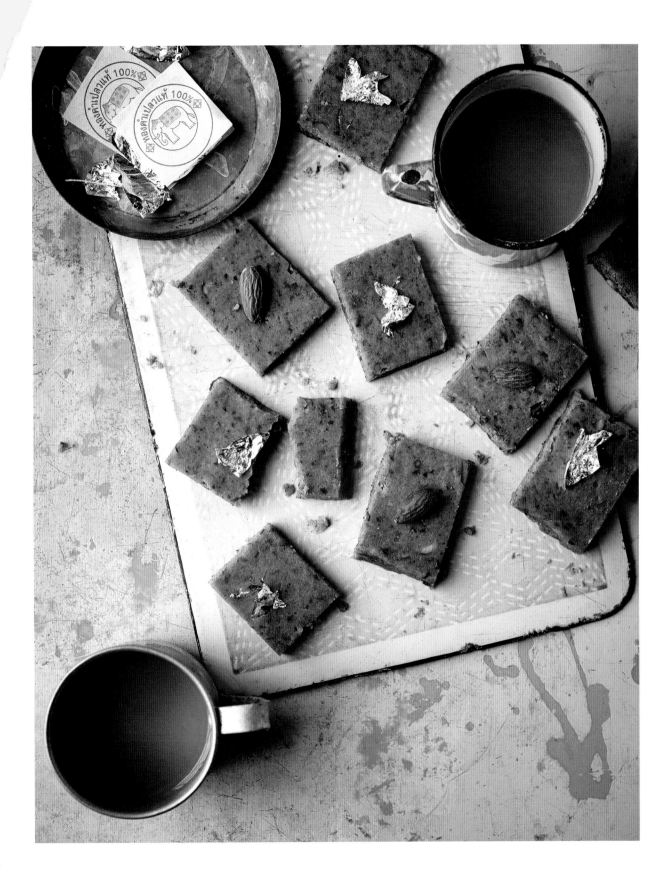

UK/US Glossary

aubergine......................................eggplant

baking paper.............................parchment paper

baking/roasting tin..............baking/roasting pan

baking tray..................................baking sheet

barbecue.......................................grill

beetroots.....................................beets

black eyed beans....................black eyed peas

cake tin..cake pan

caster sugar..............................superfine sugar

cavolo nero.................................Tuscan kale

chilli/chillies...........................chili/chiles

chilli flakes...............................red pepper flakes

clingfilm.......................................plastic wrap

coriander.....................................cilantro

double cream............................heavy cream

frying pan...................................skillet

green/red pepper....................green/red bell pepper

griddle pan.................................ridged grill pan

grill..broiler/broil

icing sugar..................................confectioners' sugar

kitchen foil................................aluminum foil

kitchen paper...........................paper towels

self-raising flour....................self-rising flour

sieve...strainer

spring onions............................scallions

sultanas..golden raisins

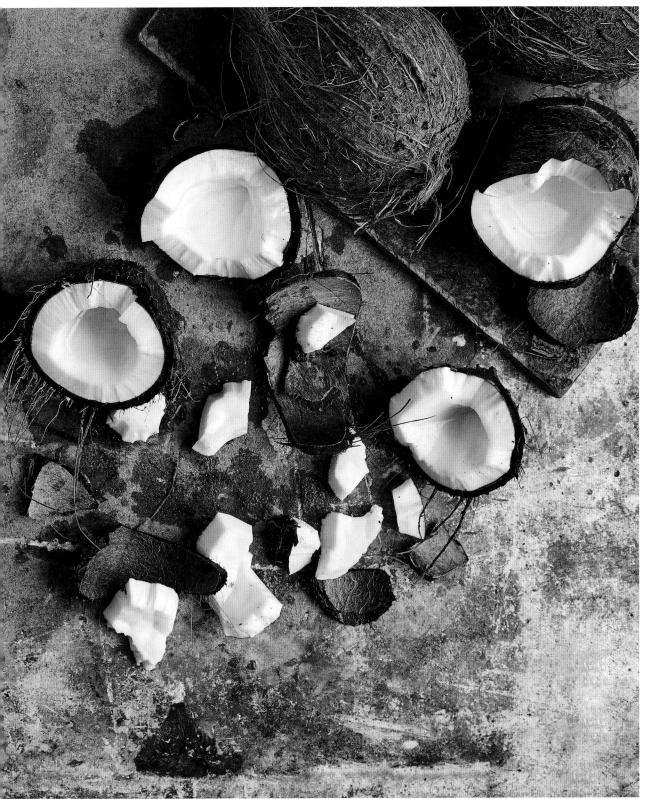

Index

Acknowledgements

With many thanks to:

My Mummy and Papa, for always inspiring me to dream big.

My sisters, Niti and Alpa, for their constant love and support.

My nephew and nieces, Vanshaj, Aashvi, Reet and Reva, for filling my heart and life with so much love.

My publisher Octopus, for giving me such a lovely team to work with.

My editor, Eleanor, for having faith in my ideas and for giving me so much creative freedom.

Leanne and Juliette, for their creativity and hard work in editing and designing this book.

My photographer, Nassima, for working so hard to get that perfect shot every single time.

Emily and Morag, for bringing my recipes to life in the pictures.

Jenni, for always helping me when I am stuck for words.

My friends, Iva and Clare, for all the love and positivity they bring to my life.

My kids, Sia and Yuv, for making me want to go that step further.

And the most important person in my life, my husband, Gaurav, for helping me to make it all happen.

Chetna Makan was born in Jabalpur, Central India. She has a degree in fashion and worked in Mumbai as a fashion designer before moving to the UK in 2004. Chetna was a contestant on *The Great British Bake Off* in 2014 and since then has written two books. Her debut, *The Cardamom Trail*, is a celebration of baking with Indian flavours, and her second book, *Chai, Chaat & Chutney*, explores Indian street food from the four corners of India. Chetna also has a very popular YouTube channel, Food with Chetna, where she shares her creative flair for all things cooking and baking.

9781784721299 9781784722876

Website: www.chetnamakan.co.uk
YouTube: www.youtube.com/c/FoodwithChetna
Facebook: www.facebook.com/chetna.makan
Instagram: @chetnamakan
Twitter: @chetnamakan

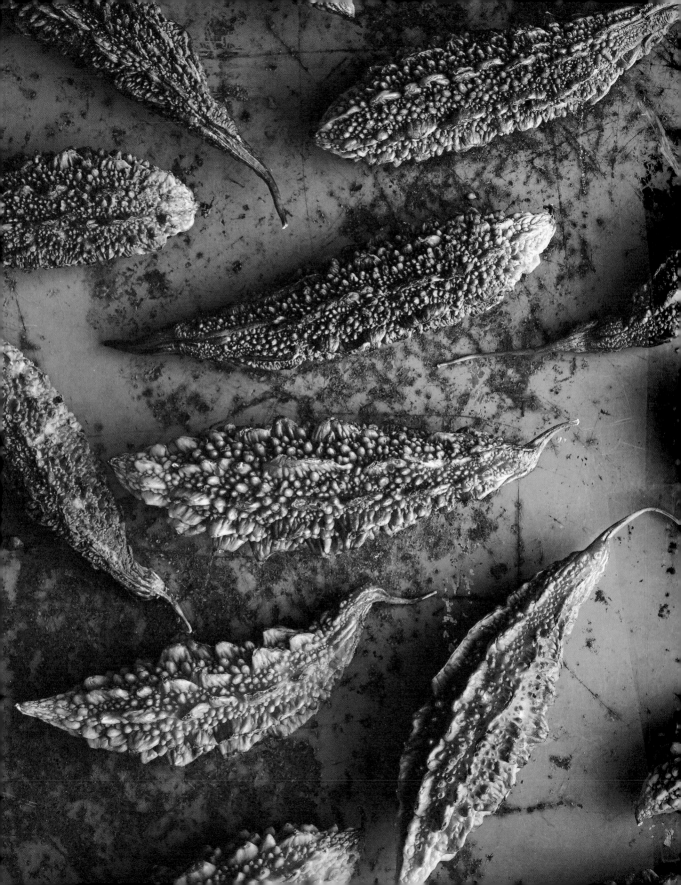